John and Anne —

To our own celebration
of our great years together
& the slope.

With my admiration, love
Judy

Ski & Snow Country

THE GOLDEN YEARS OF SKIING IN THE WEST, 1930s – 1950s

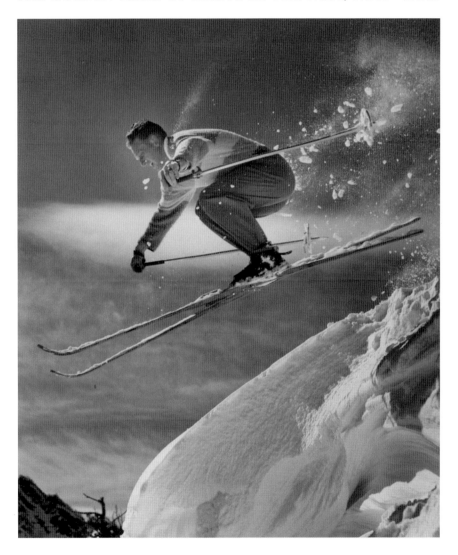

RAY ATKESON ❖ WARREN MILLER

GRAPHIC ARTS CENTER PUBLISHING®

❖

To Ray.

To Rick Schafer, for saving Ray's negatives.

To Ray's wife, Doris.

And to countless skiers who spent thousands of hours

climbing mountains to perform for Ray's camera.

—Warren Miller

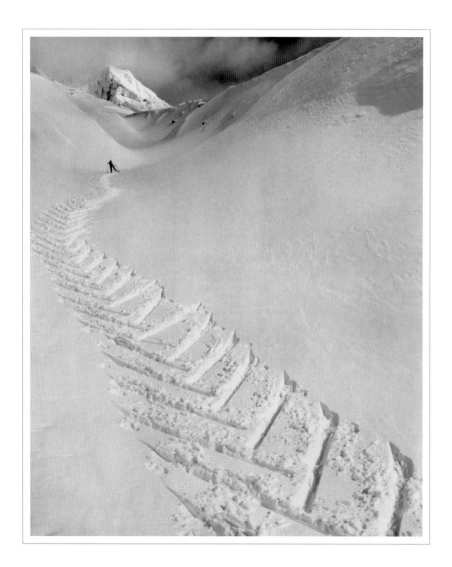

Photographs © MM by Ray Atkeson Image Archive
Text © MM by Warren Miller
Compilation of text and photographs © MM
by Graphic Arts Center Publishing®, An imprint of
Graphic Arts Center Publishing Company
P.O. Box 10306, Portland, Oregon 97296-0306
503/226-2402; www.gacpc.com

Cataloging-in-Publication Data available on request
ISBN 1-55868-538-3

President/Publisher: Charles M. Hopkins
Editorial Staff: Douglas A. Pfeiffer, Ellen Harkins
 Wheat, Timothy W. Frew, Tricia Brown, Jean
 Andrews, Alicia I. Paulson, Jean Bond-Slaughter
Production Staff: Richard L. Owsiany, Joanna Goebel
Designer: Elizabeth Watson
Book Manufacturing: Lincoln & Allen Company

Printed and bound in the United States of America

A Note to Readers: There are undoubtedly some errors
in dates, time, and places in this book due to most
events happening fifty or more years ago. I have tried
to be as accurate as my memory of the events and the
occasional phone call for verification allows.

—*Warren Miller*

This book gives a nod to all of the people (left)
whose first experience with the word "herringbone"
was while they were trying to climb up the side of a
hill on a pair of skis rather than when their parents
bought them their first suit of dress clothes.

❖

Winter is ushered in with giant snowflakes (right)
as the first storm moves in from the Gulf of Alaska,
sending the first wave of skiers to their favorite ski
shop. Ray took this shot from his window in
Portland, Oregon, in 1955.

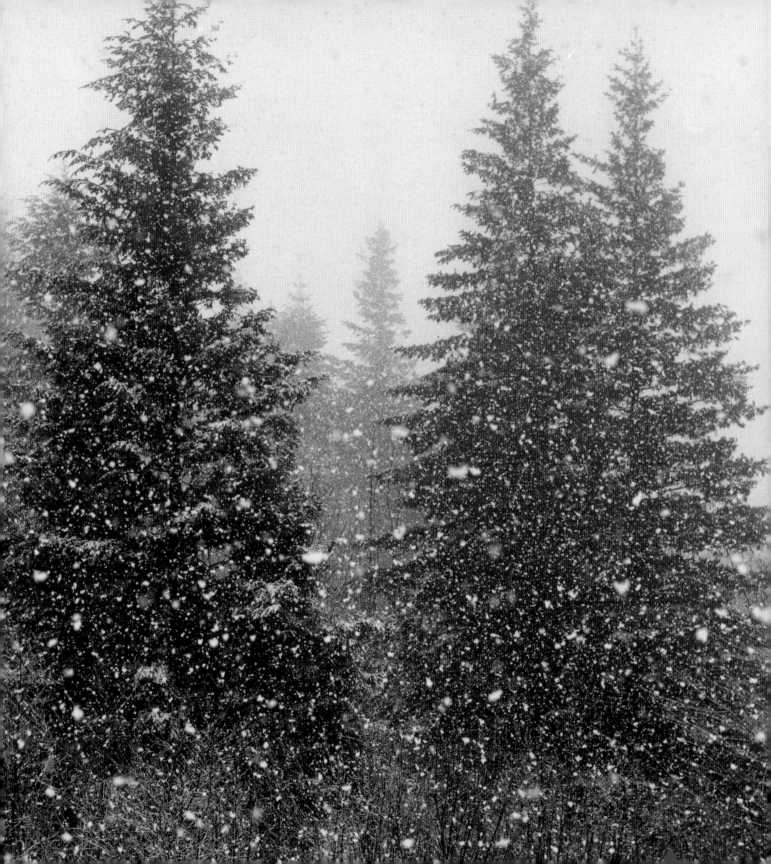

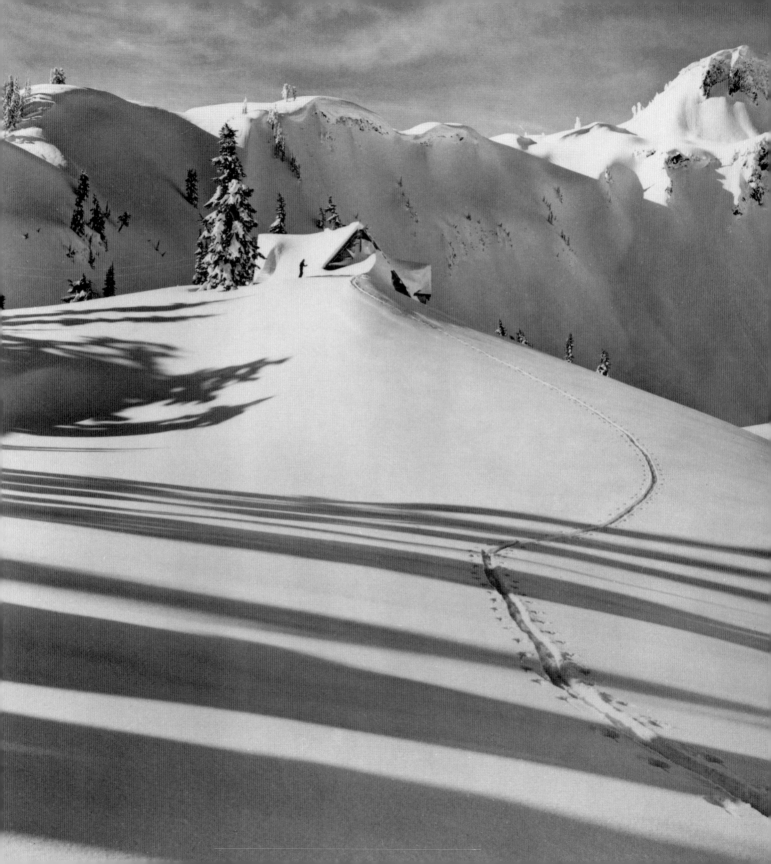

Contents

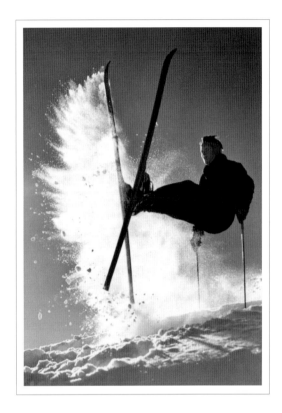

❖

This weekend of skiing in 1949 (left) took place before the invention of instant everything. A daylong climb to a mountain cabin somewhere, a good dinner, and then conversation with good friends during a nighttime snowstorm. Before skiing down the next morning you had to make the decision whether you would climb back up for one more run later in the day, or take all of your stuff back down in your rucksack on your only run of the weekend.

Ray Atkeson had to be one tough guy: look closely at the Speed Graphic camera he is holding that exposed a 4x5-inch negative. This six-pound cumbersome brute, with its complex operating mechanisms, heavy cut-film packs, and a tripod, made Ray leave the lodge hours before anyone else was up in the morning and climb with twenty-five pounds of stuff on his back to where he could get many of his famous panoramas. He was iron willed, mechanically adept, creative, and for us he was a valued historian of the formative years of skiing in the West because he started taking pictures before the invention of the chairlift.

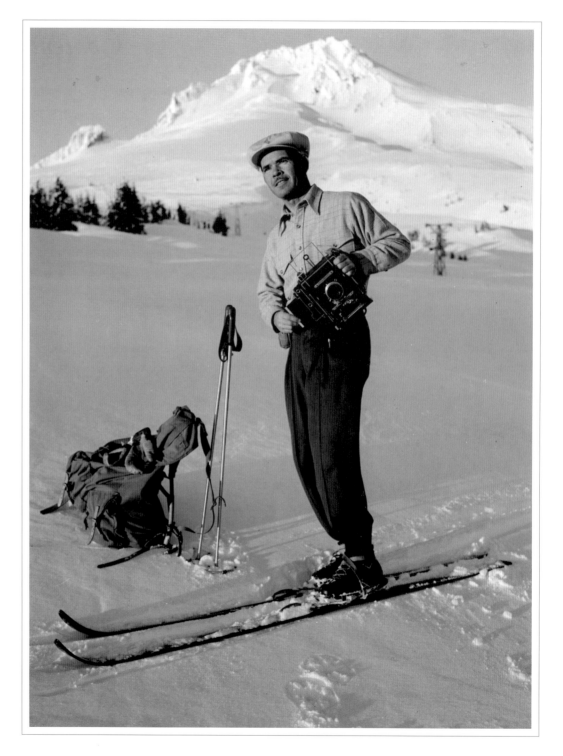

Black & White & Snow All Over

When you fly to the Northwest at five hundred miles an hour above thirty-five thousand feet, you are always astounded as you start descending and you first view Mount Hood or Mount Rainier. This unique feeling is only momentary, and in a matter of minutes your plane has landed alongside the Columbia River in Portland, or next to Puget Sound at the Seattle-Tacoma International Airport.

Lewis and Clark and their men took that same route West on their more than two-year journey with danger around every bend in the river. Try to imagine living off the land while waiting months for enough snow to melt to allow finding a way through the Rocky Mountains.

Since that expedition, countless pioneering men and women have come West, searching for a better life while responding to that compelling urge that is mankind's basic instinct, "the search for freedom." And when the developing cities got too crowded, they moved beyond the settlements.

In the 1920s, some Norwegian pioneers wandered into the Far West, where they made copies of the skis they had left in their homeland. Making them out of whatever wood was handy, they introduced some of their friends to sliding down the snow-covered hills at breakneck speed. One of them piled three neighbors in a car and invented the first "learn-to-ski-weekend."

One of those neighbors had a small box camera and a steady job operating a freight elevator for Montgomery Ward in Portland. On weekends he would hitchhike to the base of Mount Hood and climb its snow-covered flanks. Ray Atkeson found his freedom in the inhospitable land of high mountains covered with ice and snow.

This book is about Ray Atkeson and his creative vision of the beautiful black-and-white world of winter in the West. Turn back the calendar with me as you turn the pages and share what he saw. I'm Warren Miller and I will be your guide.

Ray Atkeson had a small box camera and a steady job operating a freight elevator for Montgomery Ward in Portland. On weekends he would hitchhike to the base of Mount Hood and climb its snow-covered flanks. Ray found his freedom in the inhospitable land of high mountains covered with ice and snow.

Ray's images are of a
forgotten time when
hanging onto a rope tow
or climbing for one hour
for each thousand vertical
feet of skiing was taken
for granted. His pictures
are about a time when
everyone knew everybody
else on the mountain,
when rope tow tickets were
a dollar a day, and there
weren't many rope tows to
ride, much less people who
dared to ride them.

❖

Ray Atkeson began his documentation of winter and skiing in the West during the 1930s, and by the mid 1940s he was becoming legendary with each click of his shutter. His stunning black-and-white pictures, which appeared in magazines, newspapers, and on posters for White Stag and Jantzen sportswear, sent many an indoors-in-the-winter person hurrying to the closest sporting goods store and then to anywhere someone was playing in snow.

While everyone else was having a great time skiing alongside the recently invented rope tows or chairlifts, Ray would climb up another mile or more so he could get a memorable picture of the ski area from an angle no one had ever seen before. Or he would sweet-talk the local ski school director into climbing up and jumping off something spectacular so he could capture it on film.

Ray's images are of a forgotten time when hanging onto a rope tow or climbing for one hour for each thousand vertical feet of skiing was taken for granted. His pictures are about a time when everyone knew everybody else on the mountain, when rope tow tickets were a dollar a day and there weren't many rope tows to ride, much less people who dared to ride them.

In 1936, Averill Harriman, the president of the Union Pacific Railroad, purchased several thousand acres of Idaho ranchland for four dollars an acre so he could build the first destination ski resort in North America. The ranch he bought was near a town called Ketchum. Steve Hannigan, a pioneering publicity agent who made Miami Beach famous, changed the name of that ranch to Sun Valley.

Averill said, "Our customers should not have to climb to the top of mountains to enjoy the descent on skis. Therefore we must design some type of mechanism to get them to the top more easily."

In his railroad yard in Omaha, Nebraska, during the summer of 1936, Harriman's engineers invented and built what became the world's first chairlift. They modified the same type of overhead machinery that hauled bananas from the fields in Central America to the processing plant without bruising them. First they built a large wooden scaffold out over the side of a pickup truck and hung a chair from it. Then the truck driver started driving forward and scooping up the skier who was standing on a pile of straw on a hot Omaha afternoon in June. The goal was to figure out how fast to make the chair move up the hill while the overhead cable was towing it. But the straw wasn't as slippery as snow, so they added oil to it. And it still wasn't slippery enough, so after lunch they moved to a concrete parking area. There they replaced the skis with a pair of roller

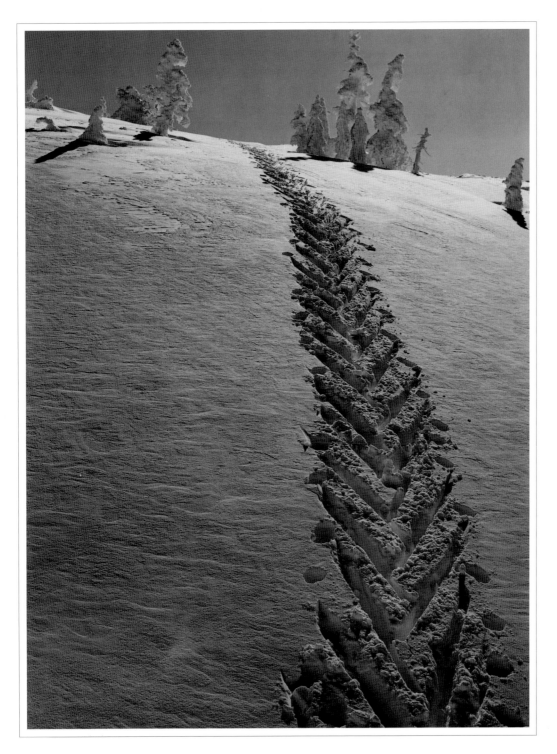

Until 1934, climbing was the only way to get up a hill in order to ski down. Powder snow was a lot more plentiful then because a quad chairlift will carry 2,700 skiers per hour at the rate of one thousand vertical feet per three minutes.

The first photo Ray took of me was in 1950 when I was teaching skiing at Squaw Valley, California.

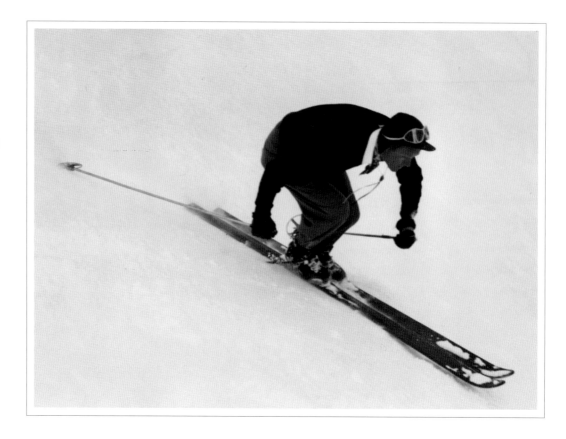

skates, and gradually the speed of the pickup truck was increased until finally the chair hit the skier too fast and hurt the back of his legs. So they slowed down the truck's speed until they settled on the same feet per minute that a fixed-grip chairlift anywhere in the world still runs today.

Once the contraption was invented, the railroad engineers set to work designing the chairlift bull wheels and all of the mechanical details we take for granted today. Six months later the world's first chairlift had been designed, built, shipped to Ketchum, Idaho, and installed in nearby Sun Valley, on Dollar Mountain in time for the Christmas vacationers. Unfortunately, the snow didn't show up until sometime in January. But the manager of Sun Valley let anyone stay free who wanted to until it finally snowed on January seventeenth.

In 1936, I was just old enough to become a Boy Scout, and on my first Scout trip, I spent the weekend playing in the snow in the San Bernardino Mountains just east of Los Angeles. Two weeks later I found a pair of skis in a garage close to where I lived

in downtown Hollywood. At the time, I was earning one dollar a week delivering newspapers, and my friends thought I was nuts because I paid two weeks' wages for the pine skis with toe straps. I considered myself very lucky, however, because my scoutmaster owned a thirty-two-dollar Model A Ford and also owned a pair of skis. The next weekend I spent my first day on skis.

It would be a decade and a half and one world war later before my path was destined to cross with Ray Atkeson's. When Ray and I met, I knew that we both had the same passion, to share with other people what we were privileged to see. Ray was a true visionary, the kind of person Einstein meant when he said, "Vision is what most people never see."

In 1942, Web Moffett bought the Mount Baker, Mount Rainier, and Snoqualmie Pass ski areas for thirty-five hundred dollars. World War II was raging, gas had been rationed to five gallons a week, and the state didn't want to plow the roads to Mount Baker and Mount Rainier. Because Snoqualmie Pass was less than an hour east of Seattle, Web prospered when skiers pooled their gas ration coupons and managed to get up there and ride the rope tows.

When Aspen opened for its first ski season of 1946–47, the ski school income and lift ticket sales for the winter totaled thirty-five thousand dollars. By 1947, Victorian houses in Aspen had already jumped from ten dollars each to more than six hundred dollars. In 1946 the ski school director, Freidle Pfeiffer, had just enough money to buy ten of them. Dick Durrance, who was the president of the Aspen Ski Corporation at the time, told me he only had enough money to buy seven. But there were enough old buildings left over from the early mining days to begin converting them to restaurants and bars as soon as the skiers started showing up.

Dave McCoy, who still owns Mammoth Mountain, California, was another pioneer ski resort builder. Soon after the opening of Sun Valley in 1936, Dave borrowed eighty-four dollars against his motorcycle to buy the parts to build his first rope tow. It, and most other rope tows, were a one-inch-diameter length of soggy, wet, hemp rope that you had to hang onto if you wanted to be hauled up the hill. Most engines that powered the endless loop of rope ran intermittently or sometimes not at all. The pioneers who built the rope tows all over the West were really dedicated, because instead of skiing, they had to work all day and most of the nights too.

In 1949, the third chairlift in California was built in Squaw Valley. About that same time, Snoqualmie Pass already had almost fifty ski instructors. The Alpental Ski Area, just across the highway, was an isolated section of land completely surrounded by Forest

It would be a decade and a half and one world war later before my path was destined to cross with Ray Atkeson's. When Ray and I met, I knew that we both had the same passion, to share with other people what we were privileged to see. Ray was a true visionary, the kind of person Einstein meant when he said, "Vision is what most people never see."

Service property. Ray Atkeson's pictures are frozen moments in time from that era—when the chairlift at Mount Hood, with its forty-foot-tall towers, was completely buried in snow for months on end and the road wasn't even plowed beyond Government Camp because Timberline Lodge had been abandoned.

Ray was one of those pioneers who had to go where other people seldom ventured. Many times he climbed up alone into the high Cascades' world of ice and snow. For example, on one New Year's Day he was the first person to climb to the summit of Mount Hood that year. And he never went climbing or skiing without his six-pound Speed Graphic camera, a lot of film, his heavy tripod, and an incredible level of energy.

Ray was the only photographer to chronicle the western mountains of America and the emerging ski industry during its early years. His Speed Graphic camera, with its 4x5 negative that was exposed by a focal plane shutter made of cloth, was a very complex camera to operate. You had to focus it laboriously with a knob attached to a cumbersome, parallax rangefinder. Once you had it focused, then you had to divide the flash bulb number by the distance to your subject, to get the right f-stop. You then set the f-stop by moving a small lever on the side of the lens. Then you had to wind the spring that powered the focal plane shutter up to whatever number corresponded to the shutter speed you wanted. By the time you did all of this, your subject was often three-hundred yards down the hill, or the clouds had shown up, or the sun had moved and you had to reposition yourself in the shade of the tree to get that backlit shot with just the right amount of light flare. At the same time you had to be careful not to point the camera at the sun too long or the sun would be focused on your cloth focal plane shutter and burn a hole in it.

It has often been said that "the difference between a good and a bad photographer is that a good one will show you a few of his pictures and a bad one will show you all of them." Ray could show you almost all of his pictures because they were all good. He shot more than 40,000 black-and-white 4x5 negatives over the years, and trying to select just 120 of them for this book was a difficult task. Fortunately, he kept good records, so together with my senior citizen memory it's been possible for me to piece together this story.

Ray was a very quiet and patient pioneer. He was also strong enough to climb in deep powder snow with all of his heavy camera gear, and he was determined to master his craft as no other winter sports photographer had ever done before. In the early 1930s before the invention of the ski lift, he climbed on skis or snowshoes to get his signature scenery shots. His compositions of trees, mountains, and carefully placed skiers are a tribute to his skill as well as his fitness.

Ray was one of those pioneers who had to go where other people seldom ventured. Many times he climbed up alone into the high Cascades' world of ice and snow. For example, on one New Year's Day he was the first person to climb to the summit of Mount Hood that year. And he never went climbing or skiing without his six-pound Speed Graphic camera, a lot of film, his heavy tripod, and an incredible level of energy.

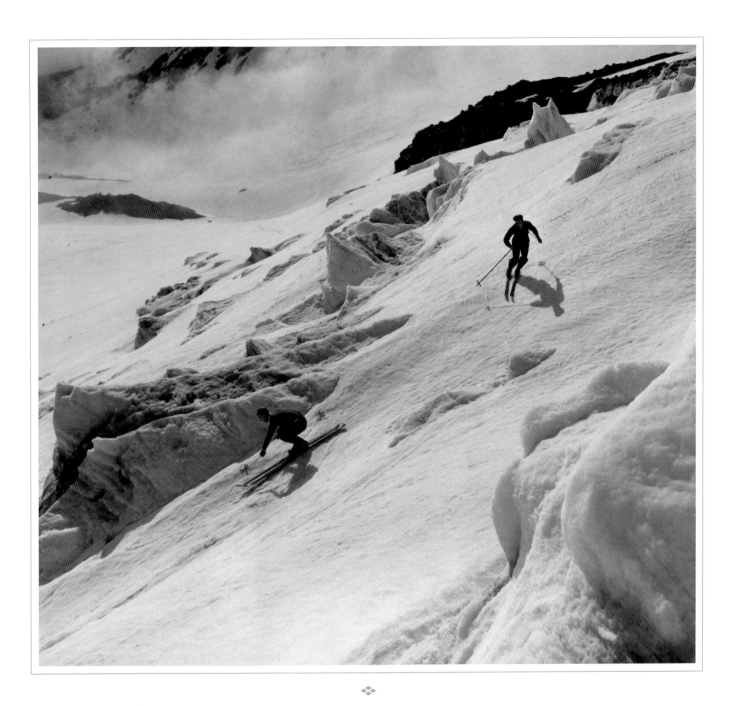

After climbing for four hours in July to ski on the Eliot Glacier on Mount Hood, Oregon, you could carve your way down through the tumbling icefalls in less than five minutes.

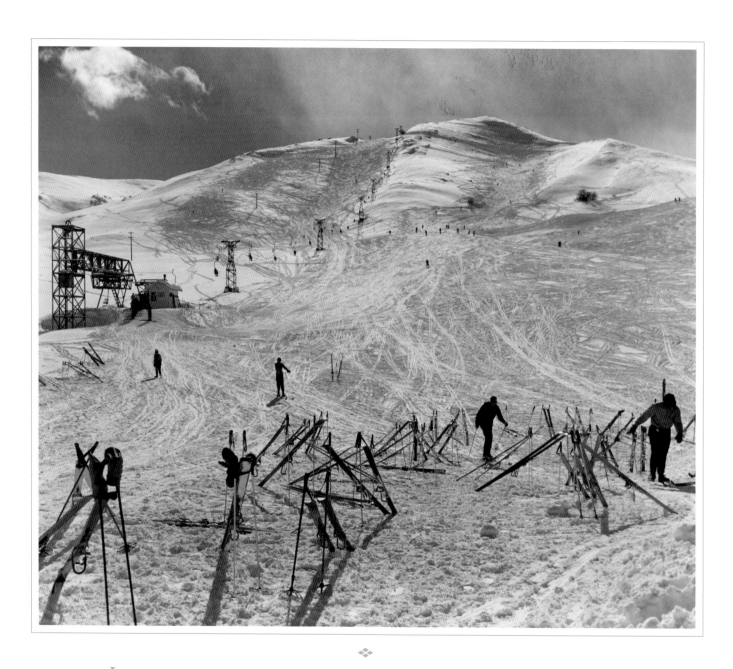

In 1936, the first chairlift built anywhere in the world was on Dollar Mountain at Sun Valley, Idaho. It was replaced in 1948 by this lift with metal towers instead of wooden ones. The double chairlift would not be invented for another two years, and the original 1936 wooden-towered chairlift was sold to Boyne Mountain, Michigan, where some parts of it are still running in the new millenium.

Don't forget that in those early days almost anyone who could turn a pair of skis was an "extreme" skier. Hardly any company made skis shorter than seven feet, and the bindings were crudely designed. When you fell, often your body would revolve and your leg wouldn't. For many people, the last run of the day was experienced while strapped onto a toboggan looking at the back of a 10th Mountain Division veteran with his feet far apart for stability but still skiing fast enough to break the elapsed time record from where you broke your leg to the ambulance waiting at the bottom of the hill.

The 1940s and 1950s were the days when an occasional pioneering skier invented things that today we take for granted. It would take many different pioneers to invent things such as safety bindings, snow-grooming machines, metal skis with plastic bottoms, snowmaking machines, double, triple, and detachable quad chairlifts, snow tires, automatic transmissions, condominiums, and the sixty-five-dollar, one-day ski lift ticket.

During the winter of 1947, the designer for White Stag skiwear made a special parka with one sleeve made out of Nylon and the other out of cotton poplin. The company wanted to find out which arm stayed the warmest, so they paid me three dollars and a one-day lift ticket to ski all day while wearing it. By that expensive experiment they thought they could figure out which fabric they should use and advertise the following winter. Both of my arms were cold all day long.

After spending two years living in the Sun Valley parking lot in a small trailer, I met Ray Atkeson early in 1950 in Squaw Valley. This was the first year that Squaw Valley was open for business. It turned out to be the winter of some of Ray's best work.

I was just starting my own filming career and I learned a lot of my work ethic watching Ray shoot his pictures. He was always the first one up and outside in the morning, and the last one to stop taking pictures at night. When everyone else was busy partying, he would still be out on the hill with his camera and flash bulbs getting that classic night shot of the lodge.

Another real pioneer, attorney Alex Cushing, built the first chairlift in 1949 in the Lake Tahoe Basin at Squaw Valley on land that had been purchased by Wayne Poulsen and Marty Arroge in the 1930s for a rumored ten thousand dollars.

That first winter, there were only four of us in the Squaw Valley Ski School plus the ski school director Emile Allais with his pioneering French parallel ski technique. Hardly anyone skied in California in 1950, so on a good day we four instructors would each have at least one pupil.

There were a dozen people working on the ski patrol, around the resort, and in the ski school that I knew could ski a lot better than I could, so I was flattered when on a

Don't forget that in those early days almost anyone who could turn a pair of skis was an "extreme" skier. Hardly any company made skis shorter than seven feet, and the bindings were crudely designed. When you fell, sometimes your body would revolve and your leg wouldn't. For many people, the last run of the day was experienced while strapped onto a toboggan looking at the back of a 10th Mountain Division veteran with his feet far apart for stability but still skiing fast enough to break the elapsed time record from where you broke your leg to the ambulance waiting at the bottom of the hill.

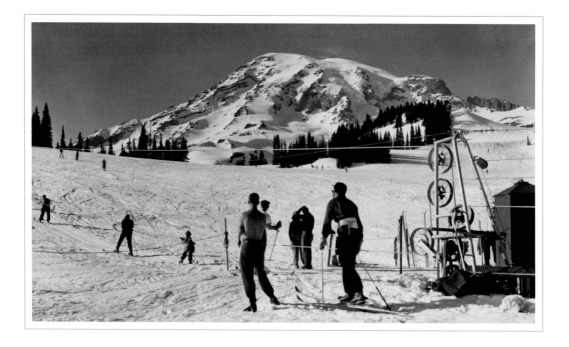

In the early days of ski lift development, no one thought about installing safety devices of any kind, including shields around the many automobile wheels that the endless rope ran around or stops to shut it off if your clothes got wrapped around the rope on the ride up the rope tow on Mount Rainier in 1938.

bright sunny morning, Ray said, "Warren would you make some turns for my camera?" This was a question I would eventually ask hundreds of other people during my own fifty-year filmmaking career. I learned a lot from Ray while we worked together, and he quickly learned that I wasn't the skier he thought I was. I learned how to be polite and persuasive when you are asking someone to jump off a cliff or to do something equally spectacular on a pair of skis that he might not want to do or even be able to do. I watched Ray and started to learn how he composed a ski action shot, about backlight, about how to trust your own eye no matter what the light meter said, how to frame a tree, a skier, and the lodge but not have the cars in the parking lot in the same picture.

Just as many pioneers do, Ray worked alone. For forty years he lugged that heavy camera and tripod all over the western United States. He would drive endless miles and shoot ski action and mountain scenery pictures for weeks on end. When he ran out of film, money, or powder snow, whichever came first, he would then return to his studio in Portland to develop the negatives and make the prints. He was always confident in his practiced ability to get the focus, composition, and exposure exactly right almost every time.

It wasn't until after World War Two that the price to ride a rope tow all day escalated to two dollars. By then Ray Atkeson had taken pictures of almost every ski resort

in the West that boasted at least one rope tow. As far as I know, he took the only photos in existence of the rope tow at Crater Lake, Oregon, a modest ski resort that operated briefly in the late 1940s.

When you tried to ride a rope tow, you had to squeeze your hands very hard around the rope until muddy colored water together with strands of hemp would be squeezed out and splatter all over your pants and parka. There was no way to ever get that mess out of your army surplus parka or your six-dollar ski pants. As the heavy and almost always wet rope was being pulled up the hill, it dragged in the snow, so when you rode it you had to hold it up off the snow. Little kids always tried to hang on right behind adults because they weren't strong enough to lift the rope and hang on while they rode up. The wet rope also twisted as it went through its journey, and if you weren't careful it would wrap your sweater in it. Then when you let go at the top, a big chunk of that hand-knit sweater your girlfriend made was still wrapped around the rope and went right on up the hill and around the sheaves of the engine. If we were lucky when the snowstorm turned to rain, there might be a small building at the bottom of the hill where we could sit and eat our peanut butter sandwiches.

When Mount Baker reopened after World War II, Ray was there riding the rope tow and climbing high on the flanks of the mountain to get great shots of Shuksan Arm and any skier he could talk into climbing for two hours with him.

When I was teaching skiing in Sun Valley, Idaho, in 1949, I was renting a garage in Ketchum, Idaho, for five dollars a month. The garage was so cold that the pot of water on the oil stove never melted all winter long. I rented floor space to Edward Scott for his sleeping bag for fifty cents a night. Scotty was a real pioneer: he invented lightweight ski poles by making smaller baskets and finding a source for lightweight tapered aluminum shafts. I even had another renter part-time, Bob Brandt, who married actress Janet Leigh; he also paid me fifty cents a night, so I was parlaying my five dollars a month rent into more than thirty dollars a month. This additional income helped me buy my first 16mm rolls of film, to jump-start my own motion picture career.

Ray and I both found our freedom using our skis and cameras, he with his Speed Graphic still camera and I with my 16mm motion picture camera.

I was lucky to have lived during that pioneering era. I still ski every day with my job as director of skiing at a new private ski resort called The Yellowstone Club in Montana. Whenever I am teaching people to ski, I tell them one very important thing, "I hope you are still skiing and enjoying life as much as I do when you are my age."

I was lucky to have lived during that pioneering era. I still ski every day with my job as director of skiing at a new private ski resort called The Yellowstone Club in Montana. Whenever I am teaching people to ski, I tell them one very important thing, "I hope you are still skiing and enjoying life as much as I do when you are my age."

Ski & Snow Portfolio

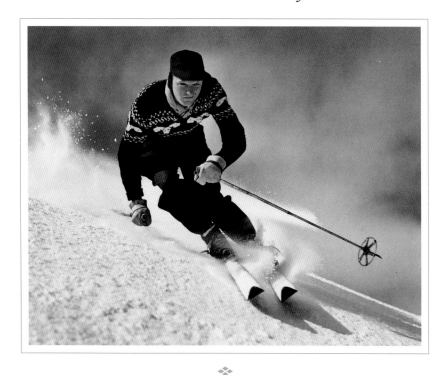

❖

I took some time out (above) from filming the Harriman Cup races in Sun Valley, Idaho, in 1950 to get this publicity photo for my then new film company. Fifty years later I am still skiing one hundred days a winter and enjoying every turn I make.

In the 1950s (right) there were a lot of dormitory-style cabins built and owned by ski clubs throughout the West because the condominium hadn't been invented yet. Often a ski weekend would be spent shoveling snow, thawing out the plumbing, and finally climbing partway up the nearby hill once or twice to ski down before heading back to the city on a Sunday afternoon. This cabin is near Government Camp on Mount Hood, Oregon.

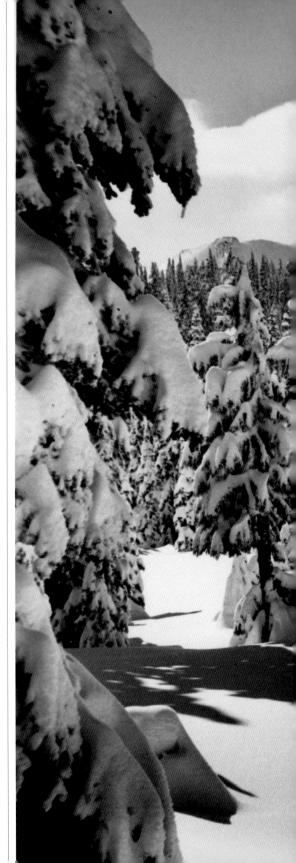

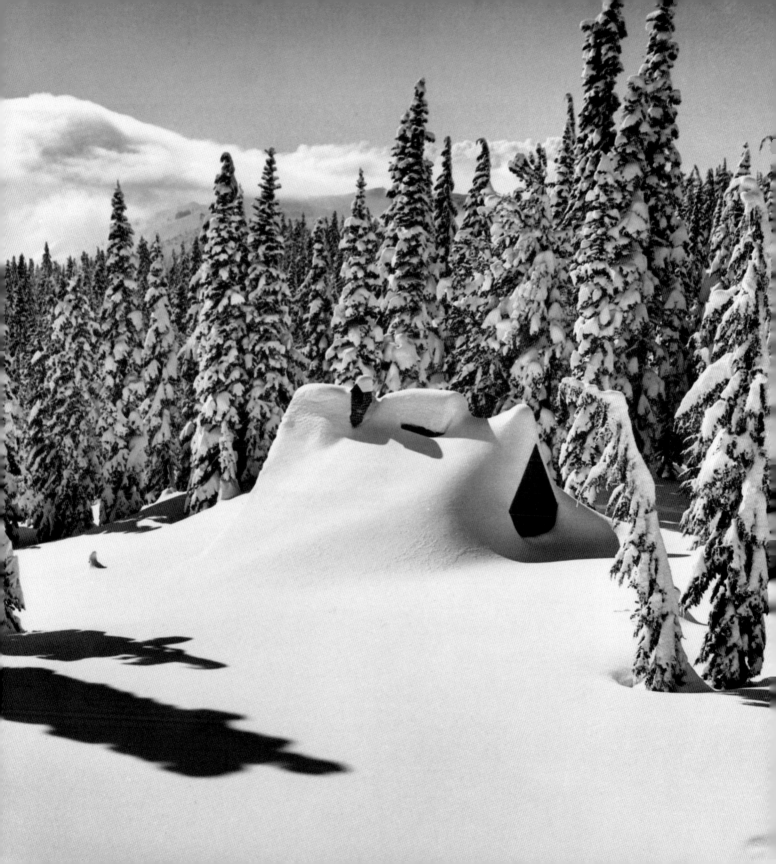

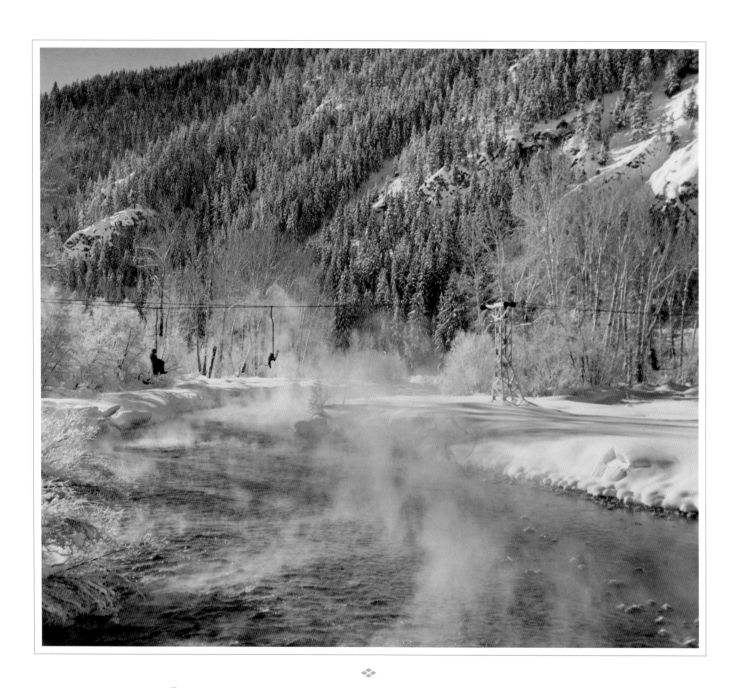

❖

Climbing onto the River Run chairlift at Sun Valley, Idaho, and floating above
the steaming Big Wood River when it is fifteen below zero has always been one
of the most memorable experiences in my lifelong love affair with skiing.

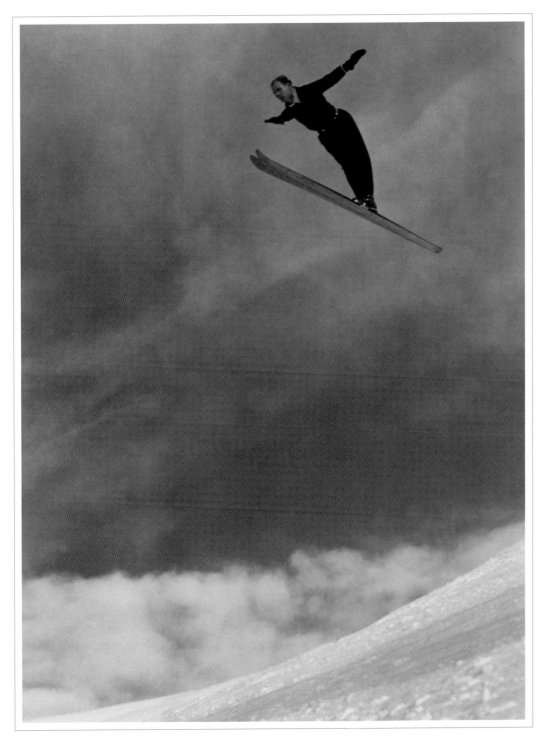

Alf Engen soars for
a new hill record on
Rudd Mountain at
Sun Valley, Idaho, 1948.
Alf was one of the two
coaches of the 1948
Olympic ski team who
trained at Sun Valley
for a month before they
went to St. Moritz,
Switzerland, to compete
in the first Olympics
after the end of World
War II.

From 1946 until all of it was sold, many skiers bought and used army surplus equipment. Skis with bindings cost seven dollars, leather boots were five dollars, leggings were a dollar, rucksacks cost three dollars, and ski poles another dollar. A complete ski outfit cost about fourteen dollars. By 1949, however, rope tow tickets had already escalated from one dollar a day to two.

The first chairlift built in Oregon was above Timberline Lodge on Mount Hood. The "Magic Mile" chairlift hill was, by today's standards, gentle enough to be called a beginner's hill.

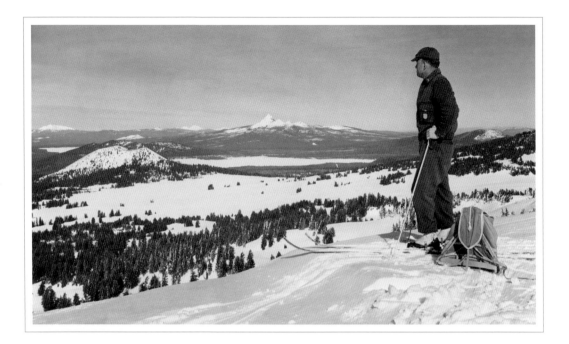

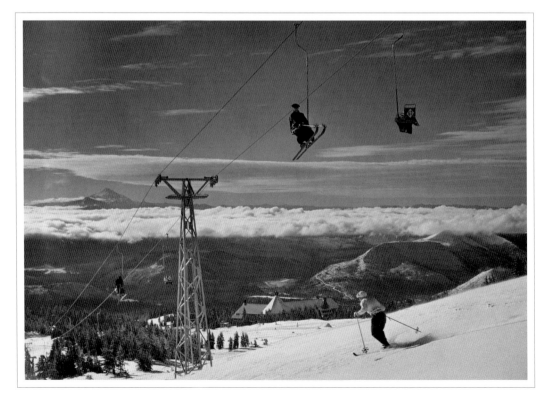

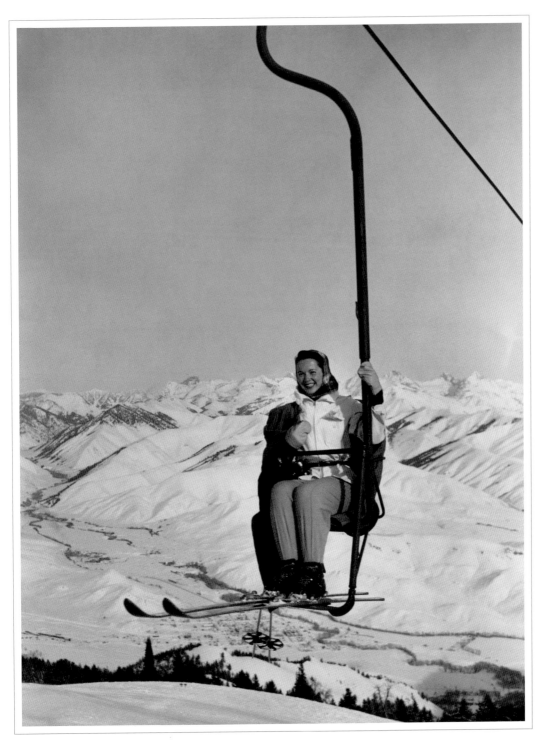

The original three chairlifts on Baldy Mountain at Sun Valley, Idaho, had footrests, a safety bar, and a heavy cape you could pull up around your shoulders when it was cold. This unique chairlift required an operator standing at the loading platform to open each arm and footrest so you could step up, sit down, and ride up. Its capacity was four hundred twenty-six people an hour.

Storms roaring in from the Pacific often brought the Magic Mile Chairlift to a halt in 1948. Today, chairlifts are run twenty-four hours a day during severe storms so ice can't build up.

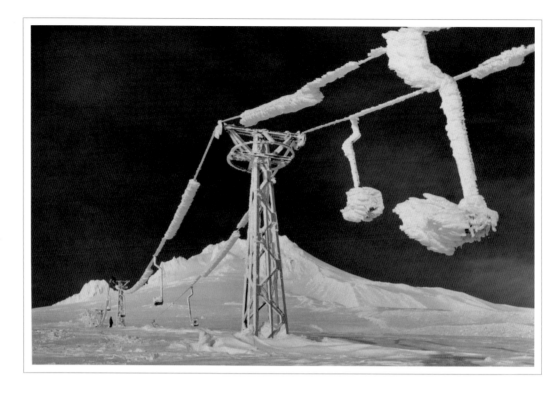

Whoever designed The Magic Mile lift on Mount Hood didn't do enough research before deciding how tall to build the lift towers. After some storms a mile-long ditch would have to be shoveled out by hand so skiers could ride up, but the next high wind would fill it right back up with snow.

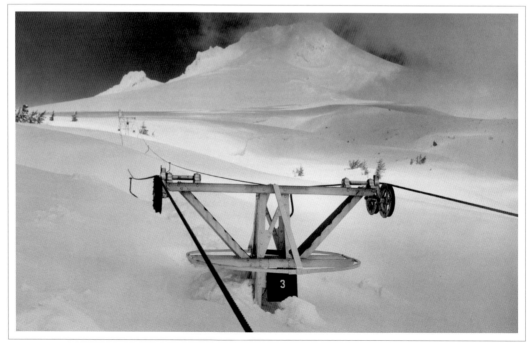

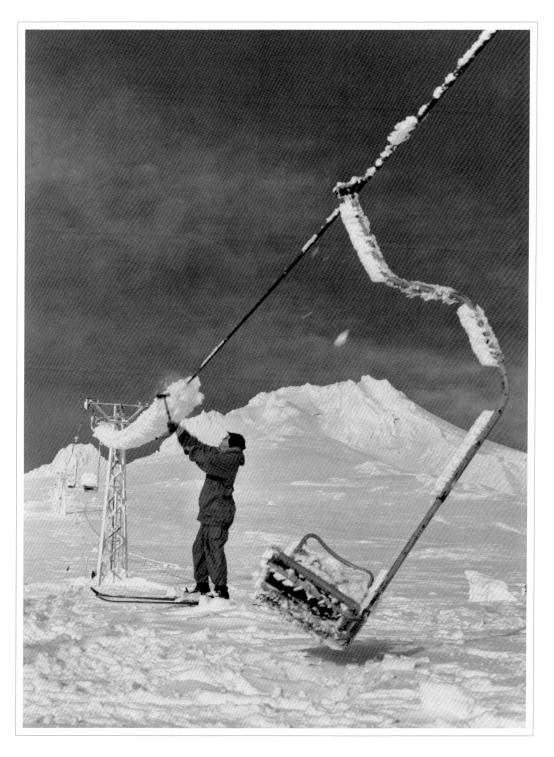

After a big storm it was necessary to climb up under the chairlift and beat the ice and snow off the cable and chairs. Sometimes it snowed and blew hard enough to tear the Magic Mile cable right off the towers.

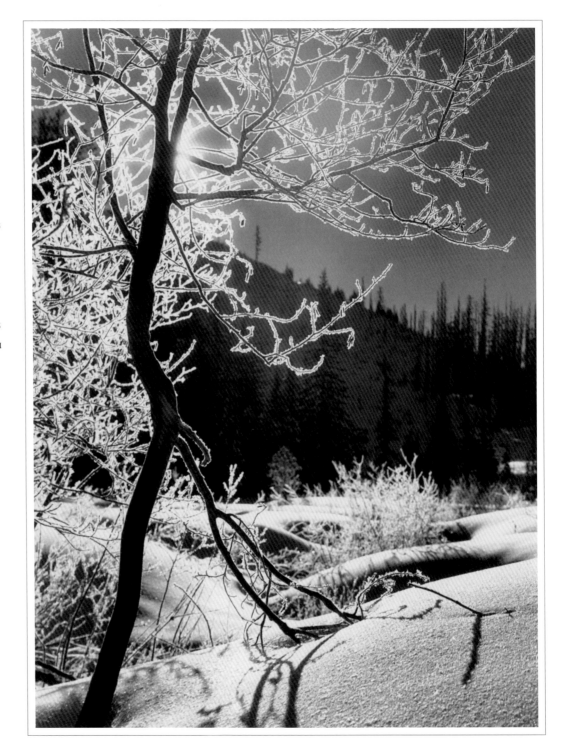

Hoarfrost condenses on the trees at night and usually melts within an hour after the morning sun hits it. Ray Atkeson was always the first one out of bed, with a dedication that separated him from other photographers of his era. This behavior is still a must today. If you want to get good pictures you have to be finished with breakfast and out working before the rising sun casts the first long shadows.

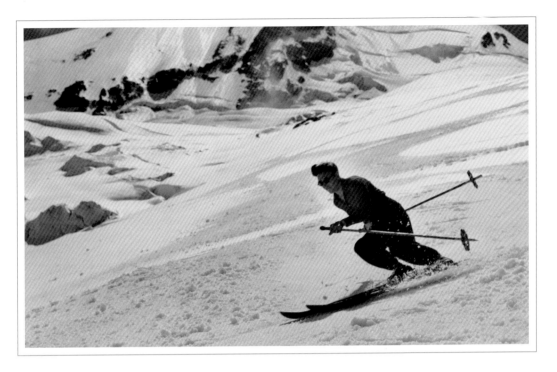

Statistics tell the story here. This is a five-foot seven-inch skier on seven-foot three-inch skis, using four-foot-long, one-pound ski poles with one-pound baskets. It's a wonder that anyone in 1946 ever decided to take up skiing.

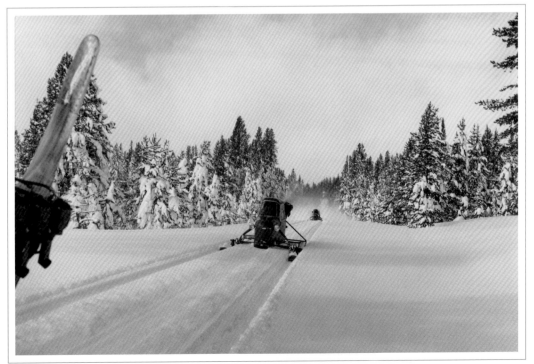

These 1940 snowplanes head for Old Faithful in Yellowstone National Park. The roaring engines and whirling propellers frightened away any wildlife that might have been within two or three miles.

The white ghosts of Mount Hood are bent double by their heavy mantle of snow while waiting for the first warm day of spring so they can again stand upright.

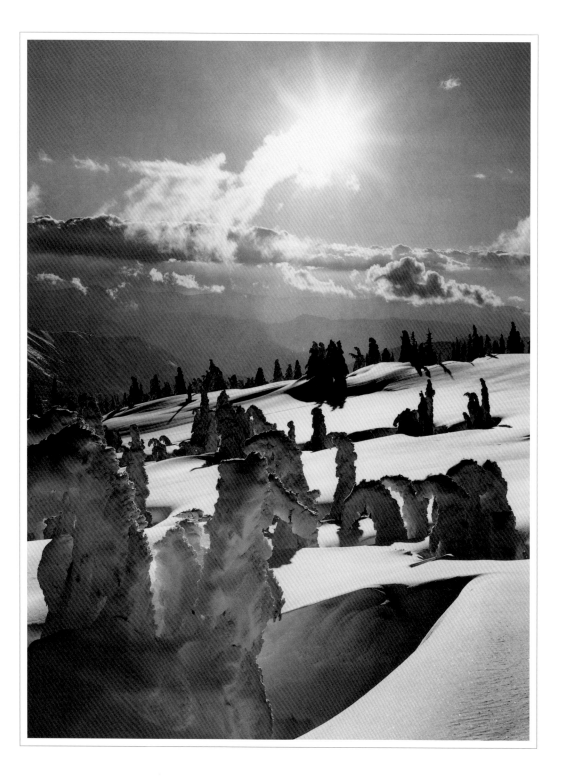

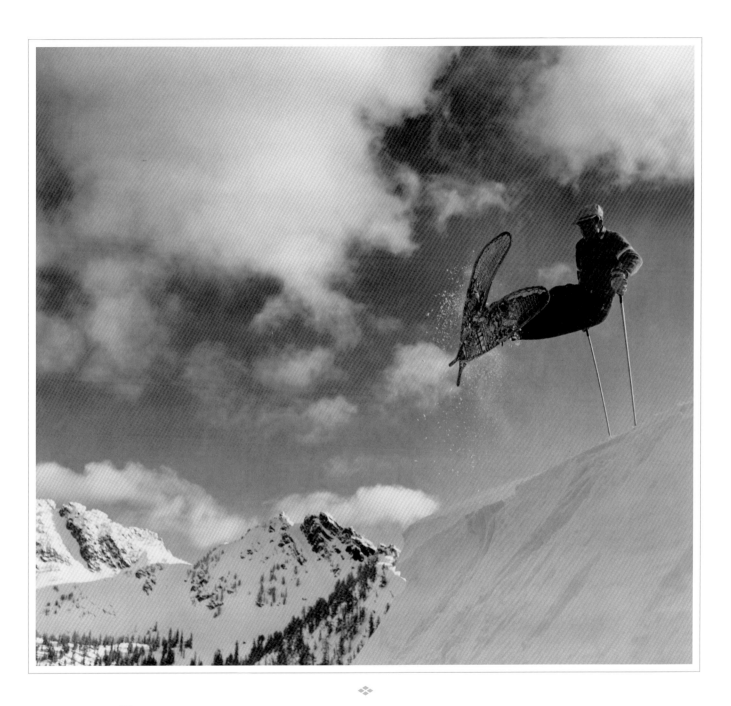

Freestyle in the 1950s wasn't limited to skis. Olaf Rodegard at Blue Mountain, Anthony Lakes, Oregon, shows what four years in the 10th Mountain Division ski troops taught him.

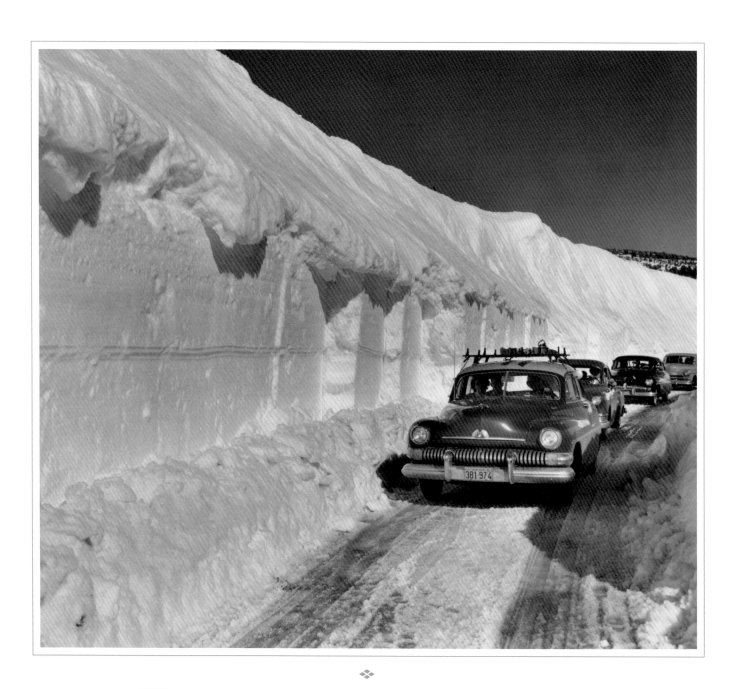

What kind of a view would you have from a first-floor hotel room if there were twenty feet of snow, like here on the road to Timberline Lodge, Oregon? Good architectural design compensated for such massive snowfalls on Mount Hood in 1951.

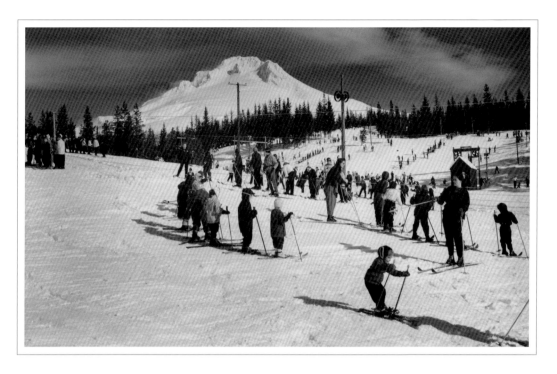

In the 1950s and '60s, everyone took a lot of ski lessons and the average number of pupils per instructor was about a dozen. Most ski schools didn't let you ride the rope tow until you had learned how to climb up the hill and ski down while making good snowplow turns. This took the average student about four or five days of climbing to accomplish.

❖

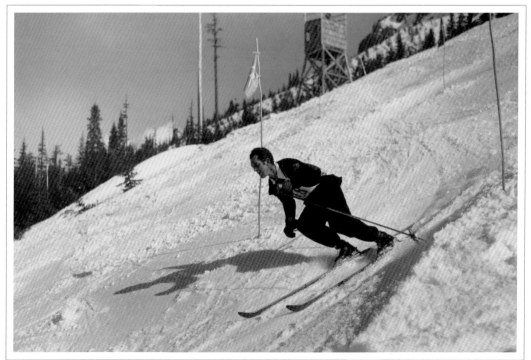

Jerry Hiatt races in a giant slalom on very long skis. Soft leather ski boots and cumbersome equipment made ski racing very difficult in 1949. After finishing his ski racing career, Jerry became a dentist and settled in the San Fernando Valley, California, which is a long way from a destination ski resort.

The roof of this cabin is about twenty-five feet above the ground, and during 1950s winters on Mount Hood, Oregon, it was completely buried under deep snow.

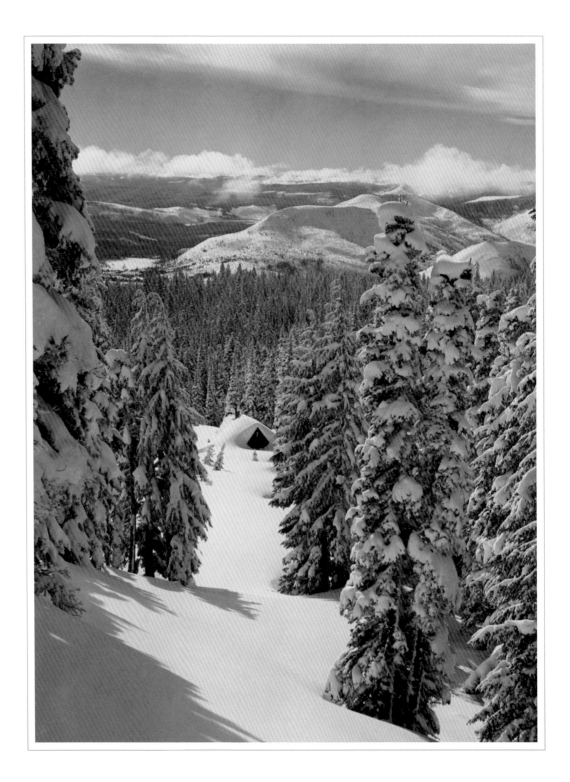

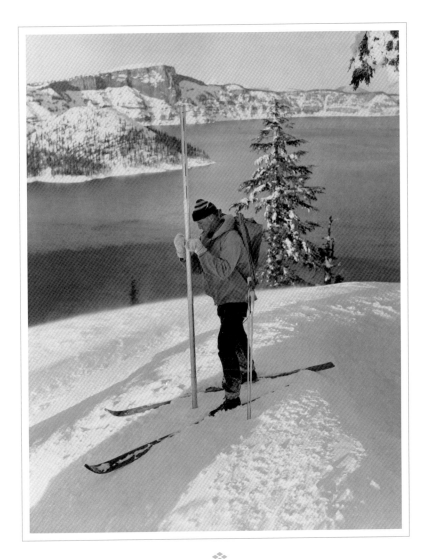

In 1947, world-famous ventriloquist Edgar Bergen was in Sun Valley without his dummy, Charlie McCarthy, but he did have his then-state-of-the-art home movie camera, a 35mm Bell and Howell three-lens turret, army surplus combat camera. The turret held a wide-angle lens, a normal lens, and a telephoto. It weighed more than ten pounds, and in 1947, a minute and a half of color film cost about thirty dollars.

A snow surveyor (above) at Crater Lake, Oregon, in 1949 inserts several telescoping sections of hollow tube deep into the snow. He will extract a core of snow and weigh it for moisture content, so farmers can plan on how much water will be available for irrigation the following summer.

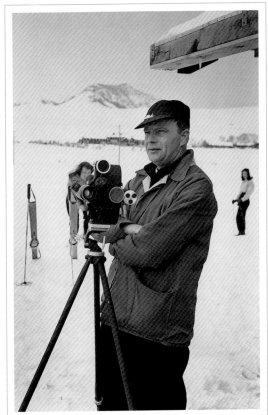

Ray's vision caught this ghostly face wearing a pair of white glasses in a meandering stream somewhere in Oregon in 1952.

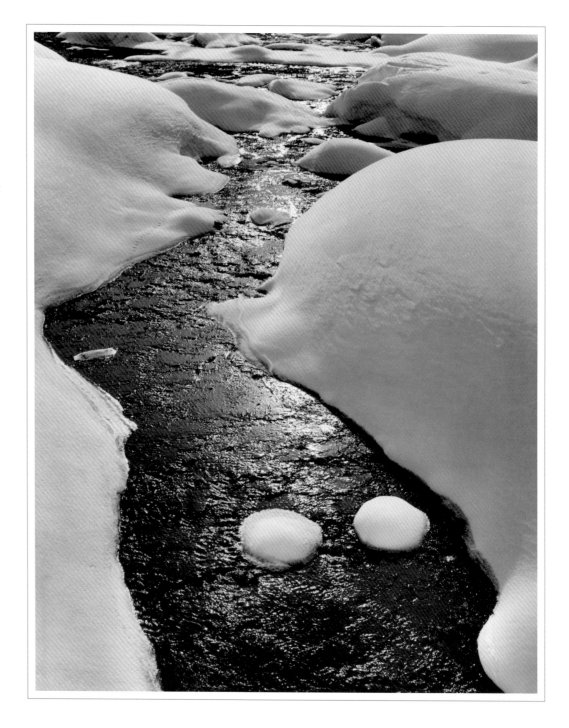

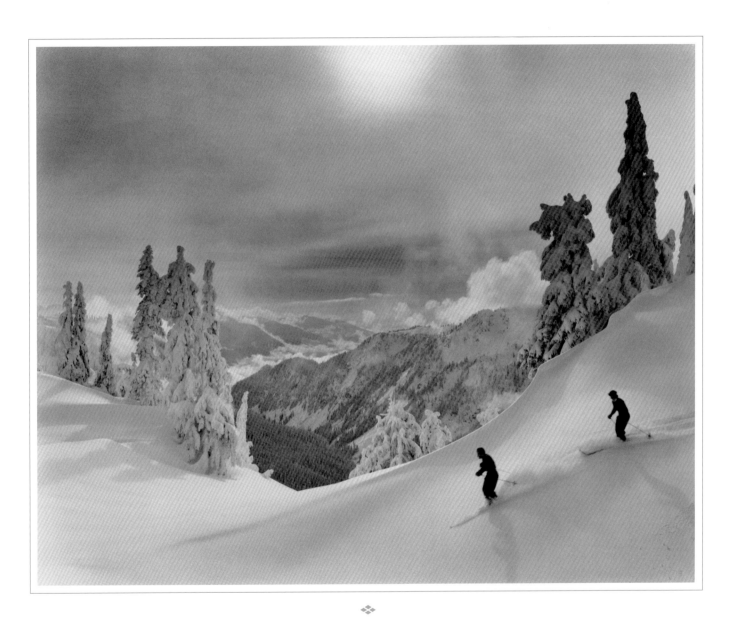

❖

An unwritten rule of the mountains fifty years ago was
that the man always got to make the first set of tracks.

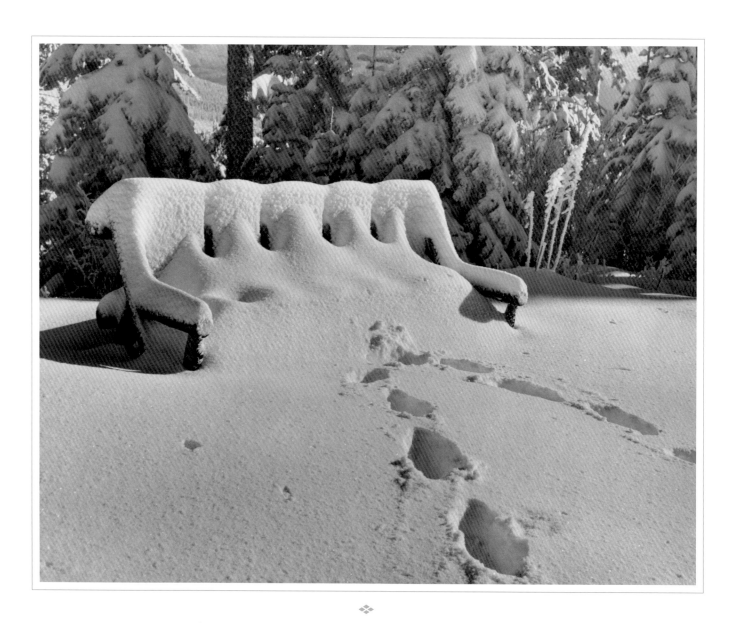

A sun-drenched bench waits for the snow to melt so that you can
sit on it in the spring and lament the passing of another ski season.

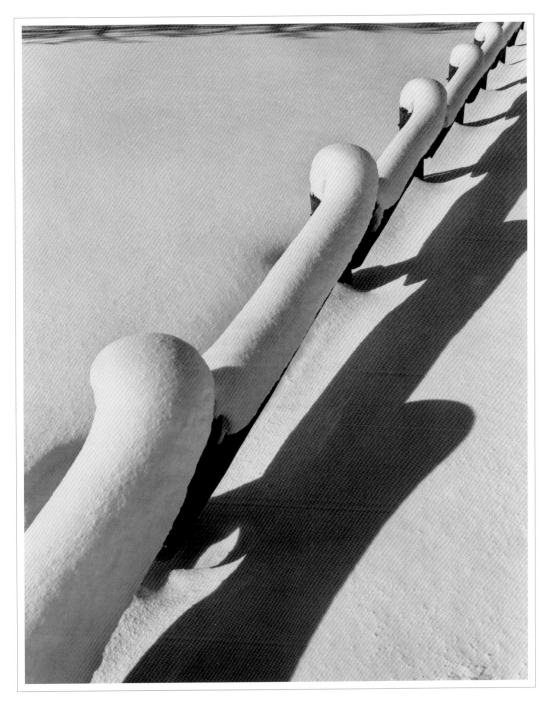

Geometry and curves captured by Ray's vision form images that are seldom noticed by anyone else unless they can look at his 1947 pictures.

Carving turns in untracked powder snow in the late 1940s wasn't reserved for men only. There were some women who could climb faster and ski better than most men, as demonstrated by Alma Hansen on the flanks of Mount Baker, Washington.

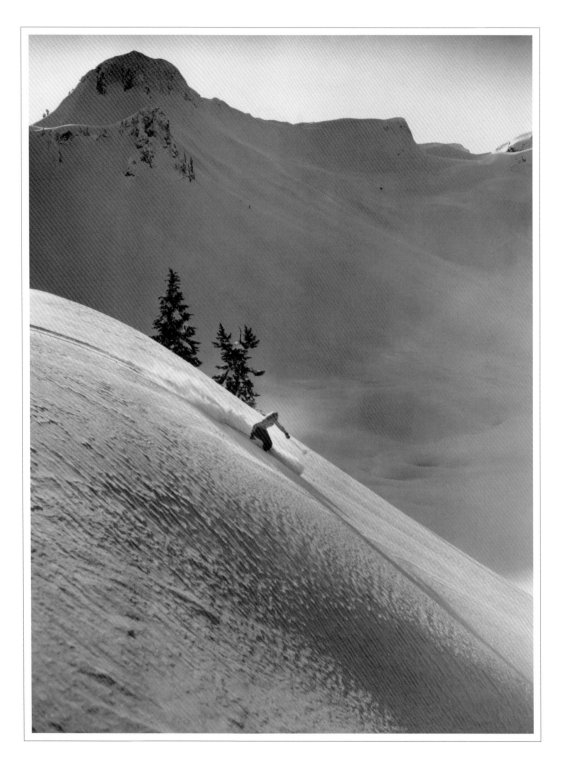

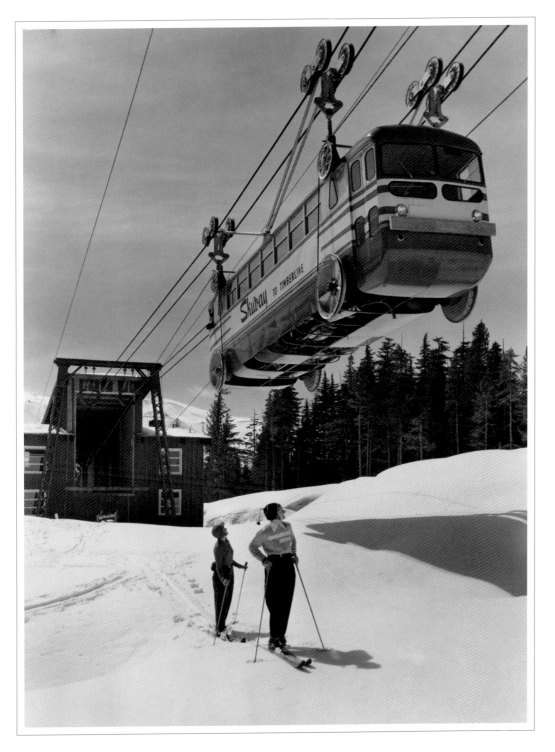

In 1953, this one-of-a-kind lift was built from Government Camp to Timberline Lodge on Mount Hood, Oregon. If you trace the path of the lower cables, you can see that they went down and around the original four wheels on the bus. The same engine that ran the bus on the streets of Portland still powered the rear wheels. The bus was supposed to drive up to Timberline Lodge high above the deep snow and eliminate the need to plow out the road. It didn't work!

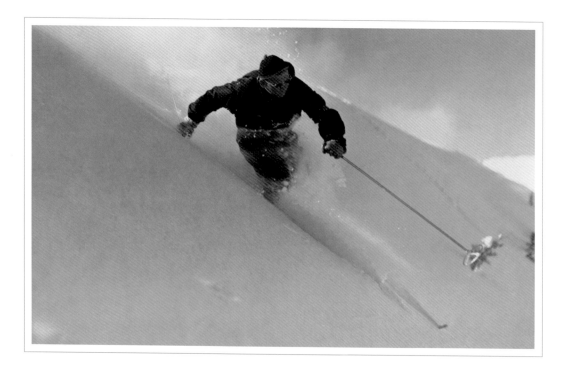

Never mind what all of the technique manuals said in the 1950s, a lot of rotation of the upper body was necessary to turn a long stiff pair of skis in deep powder snow. Alf Engen demonstrates how he made his skis turn.

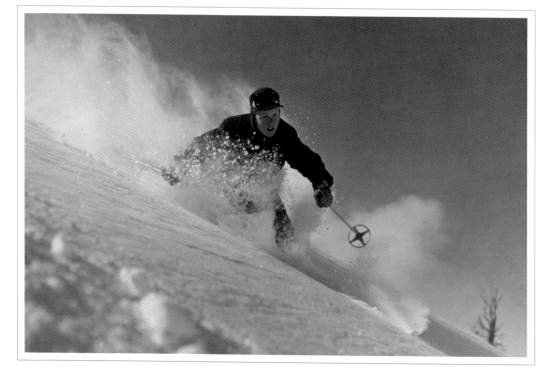

Alf Engen's son Alan at the age of twelve, following in his famous father's footsteps in the deep powder at Alta, Utah. In 1992 Alan succeeded his father as the ski school director.

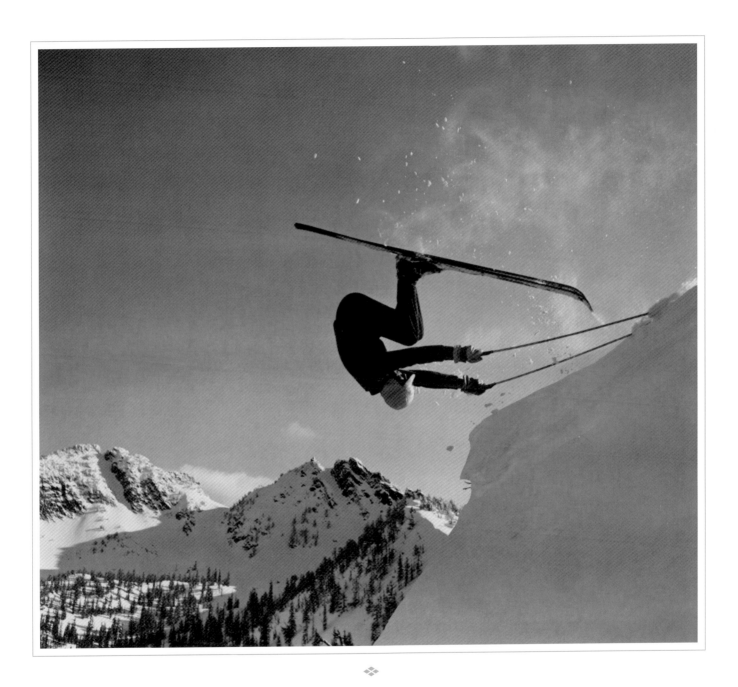

Freestyle skiers of today owe thanks to the antics of their grandfathers in 1949. One of them is seen here doing a front flip off a cornice on seven-foot, six-inch skis. Today's freestyle skiers, with their triple-twisting quadruple back flips, use skis about half this length.

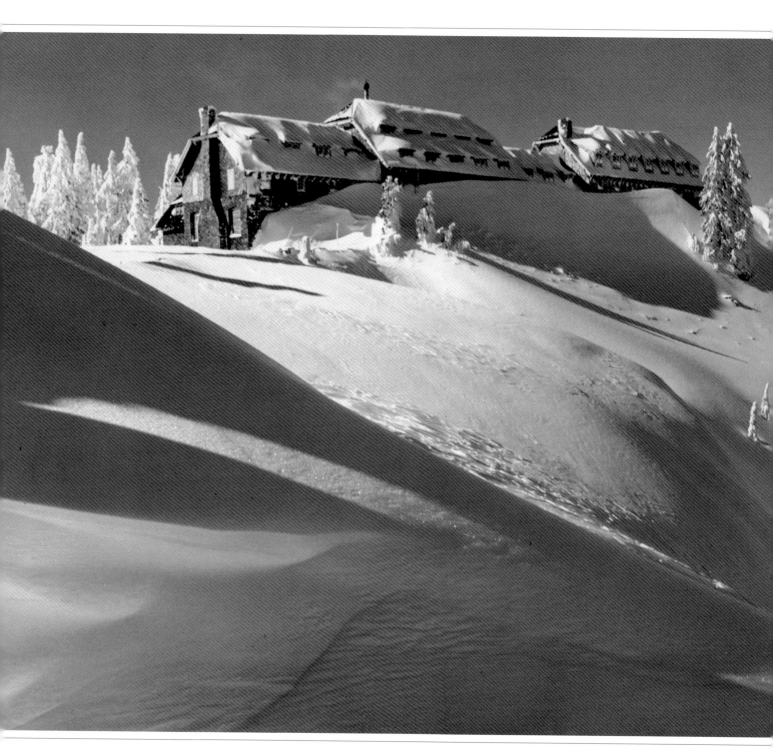

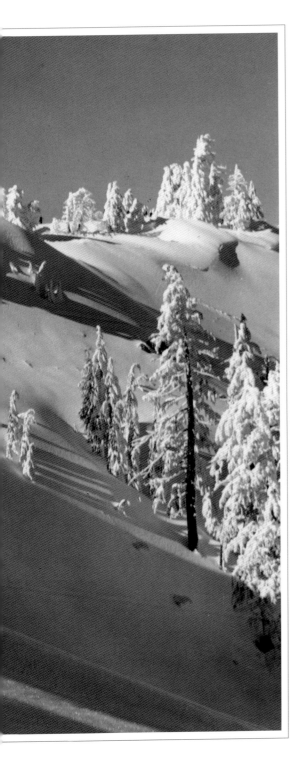

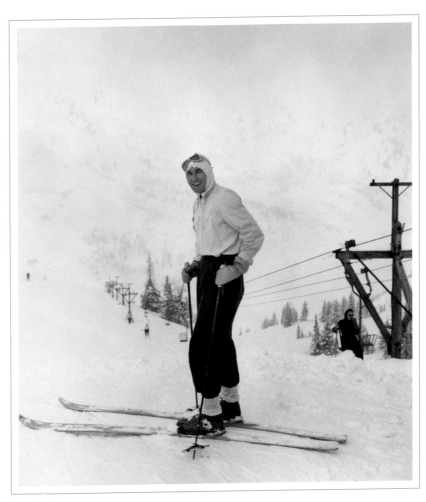

❖

Errol Flynn (above), 1940s film star, was one of the many Hollywood celebrities who skied at Alta, Utah, and rode on this wooden-towered chairlift that cost $10,000 to build in 1938.

The massive lodge (left) at Crater Lake, Oregon, served as a ski lodge for a few years after World War II. Two facts contributed to the ski area's short life: it was located a long distance from any large city and only had rope tows.

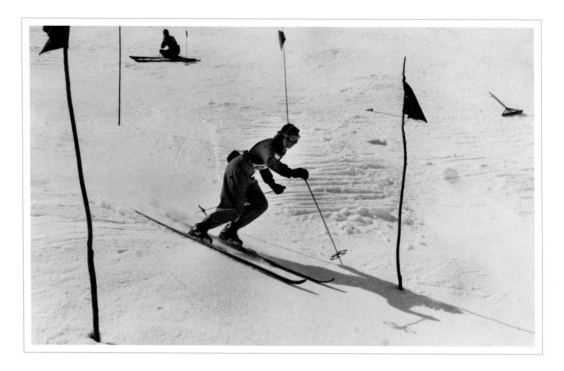

In about 1949, Jeannette Burr switched from water skiing to snow skiing and within two years was a member of the U.S. Olympic ski team. No one thought about the wind resistance of ski clothes, so twenty-seven-inch knees in your ski pants were fashionable, photogenic, and made you go slower.

In 1948 at Jackson Hole, Wyoming, there was only one chairlift and it was on nearby Storm Mountain. That year you could buy a vacant lot right next to the lift and on the edge of town for about five hundred dollars. In the distance are the Grand Tetons where Jackson Hole Village, the tram, and chairlifts would be built almost twenty years later.

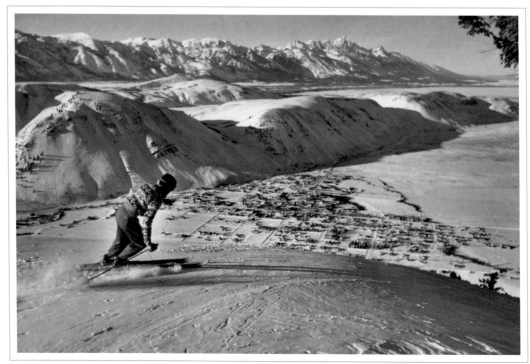

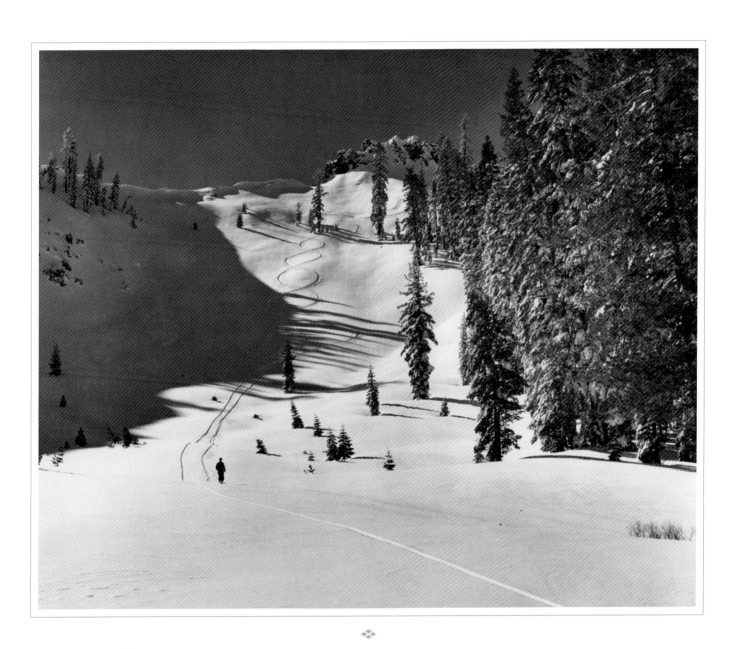

Lots of untracked snow was easy to find at Sugar Bowl on Donner Summit, California, until as late as 1990. Until then you had to ride a mile-long gondola from the highway to the resort, so there were never very many people there. Today a quad chairlift allows as many as 2,700 sets of ski tracks an hour to be made on the same hill. In 1952, these two sets of tracks were made about an hour apart because the same skier had to climb twice to make them.

Ray had a unique way to make backlight change a ho-hum scene into a spectacular picture. This 1949 extreme skier loaded up the tops of his skis with powder snow before jumping up between his poles and landing with them pointed ninety degrees away from where he started.

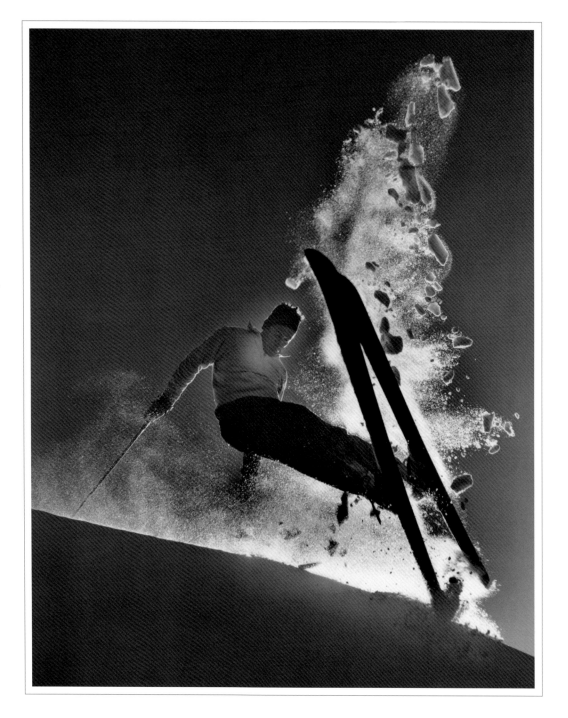

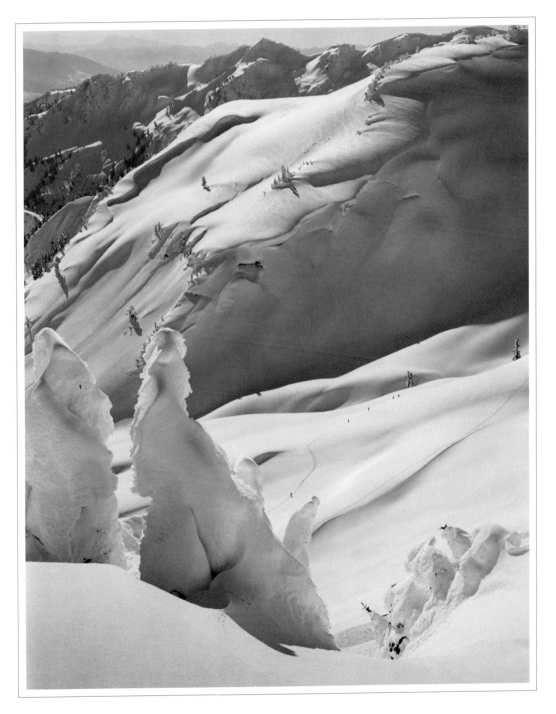

Ray left the cabin with his twenty-five-pound rucksack full of camera gear an hour before the climbers way down below him left for Table Mountain in northern Washington. During the 1940s and 1950s it was normal to climb for four or five hours with sealskin climbers on the bottom of your skis. When you got tired, you could sit on a rock, soak up the sun, eat lunch, and then take that one delicious five- or six-minute run down.

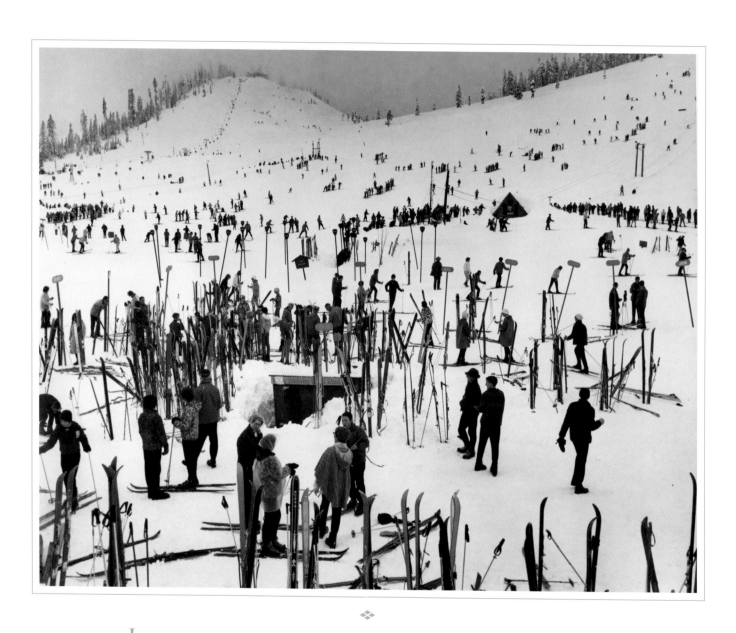

In 1942 for $3,500, Web Moffet bought Snoqualmie Pass, Washington, together with the Mount Baker and Mount Rainier ski resorts. By 1954 he had sold the Baker and Rainier ski resorts, and here at Snoqualmie Pass he had built eleven more rope tows and opened his first chairlift. By then, on any weekend hundreds of ski instructors taught thousands of new skiers how to enjoy making turns, if and when they could find enough space to make turns.

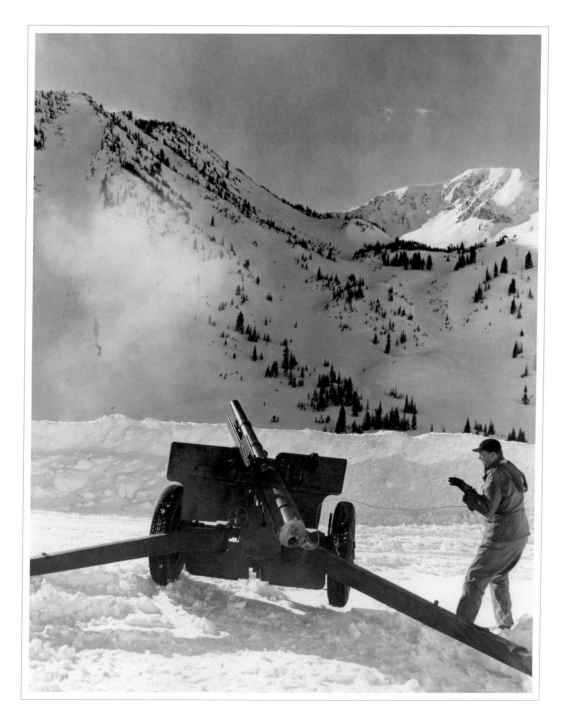

In the 1950s, army surplus artillery shells were the least expensive way to shoot down avalanches at Alta, Utah. Sometimes, the wrong altitude would be cranked into the artillery piece and the shell would pass above the top of the mountain and explode in the next canyon.

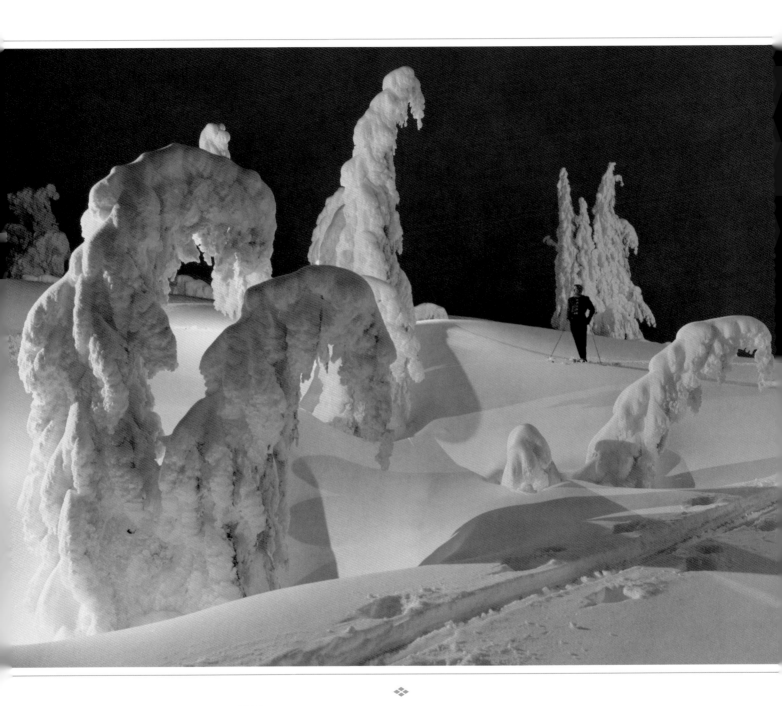

Waiting in the predawn darkness, this skier will be the first
one in line when the ski lift starts running in a couple of hours.

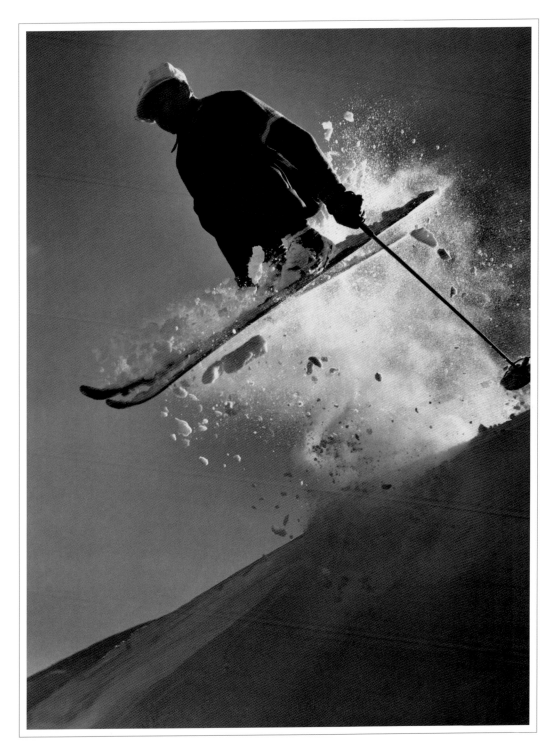

Ray Atkeson was one of the first photographers to utilize backlight to dramatize action. Here in 1952, Olaf Rodegard, with his long skis and big-basket ski poles, jumped off a cornice into Lookout Bowl at Sun Valley, Idaho.

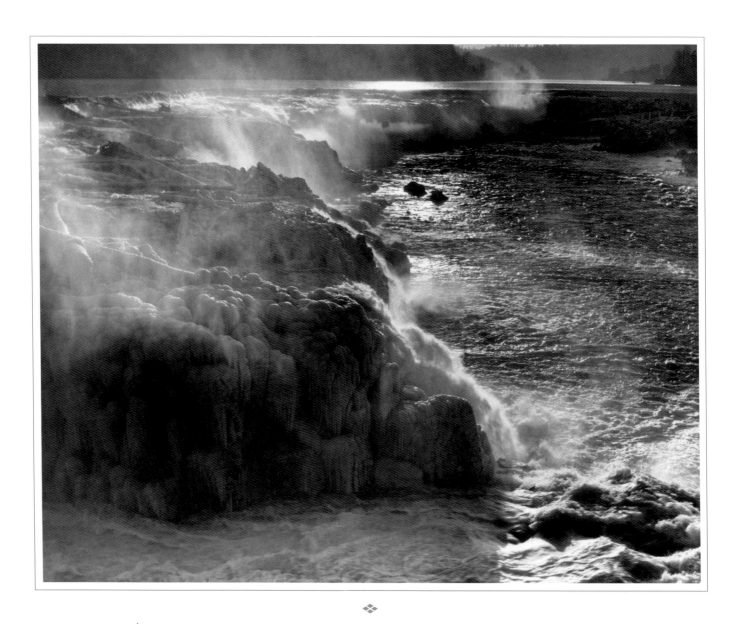

❖

A small river from a high mountain lake flowing over the rocks is exposed to freezing cold air long enough to create an image that should make you feel cold, even on a hot summer day.

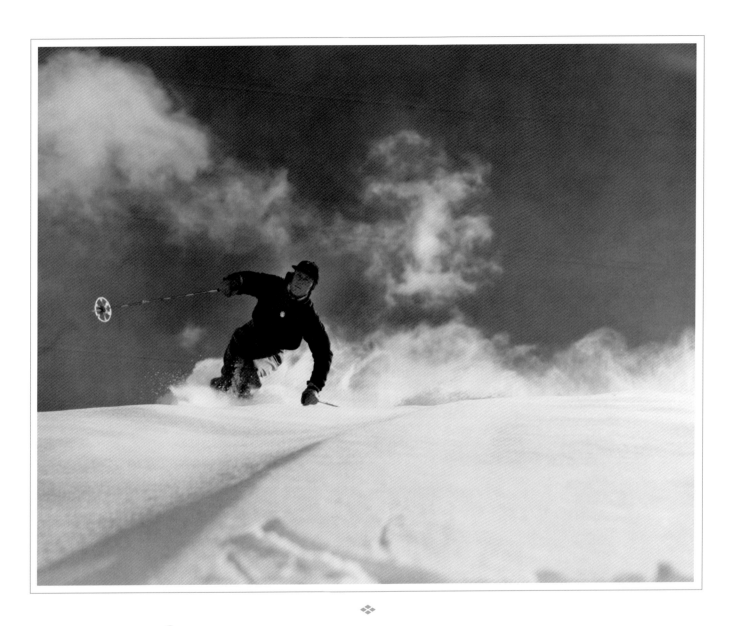

Sigi Engle directed the ski school at Sun Valley, Idaho, for almost thirty years.
Students in his private lessons were from all walks of life, as long as they were
famous and were either politicians, industrialists, or movie actresses.

Jim Patterson starts a racer in the Gold Sun downhill race from in front of the Round House at Sun Valley, Idaho, in 1948. If your eyes are good enough you can see me in my T-shirt in the lower right-hand corner.

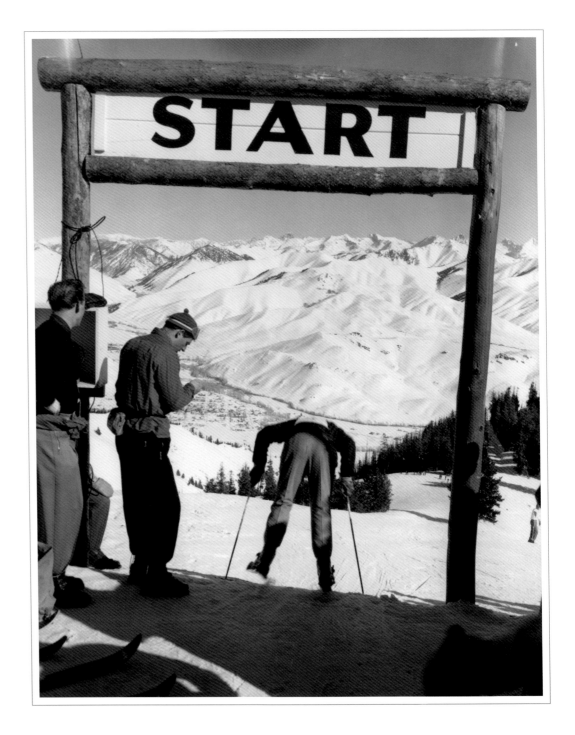

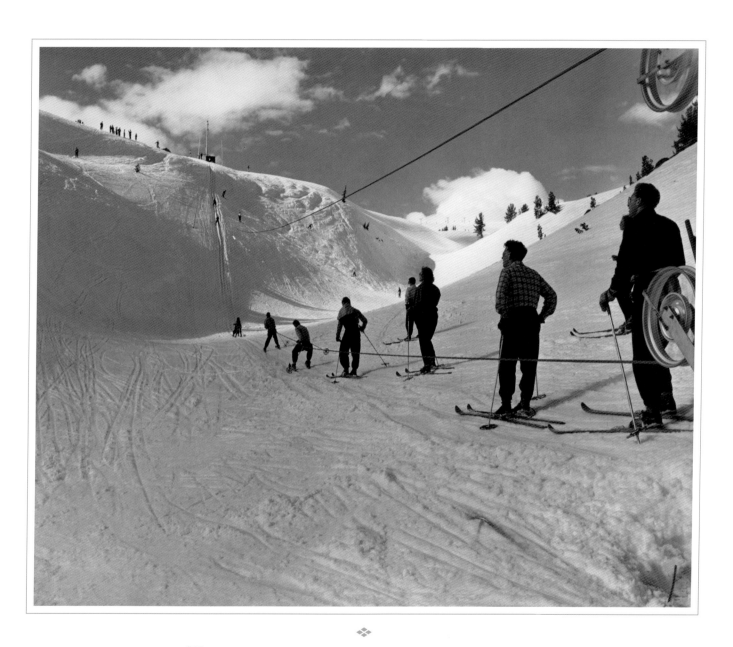

The Salmon River rope tow on Mount Hood, Oregon, seen here in 1949, was for experts only because the hill was so steep and no one thought about safety guards around the lower sheaves of the tow.

R ay caught the ghosts of Mount Hood with his composition and just a hint of clouds in the background during January of 1952.

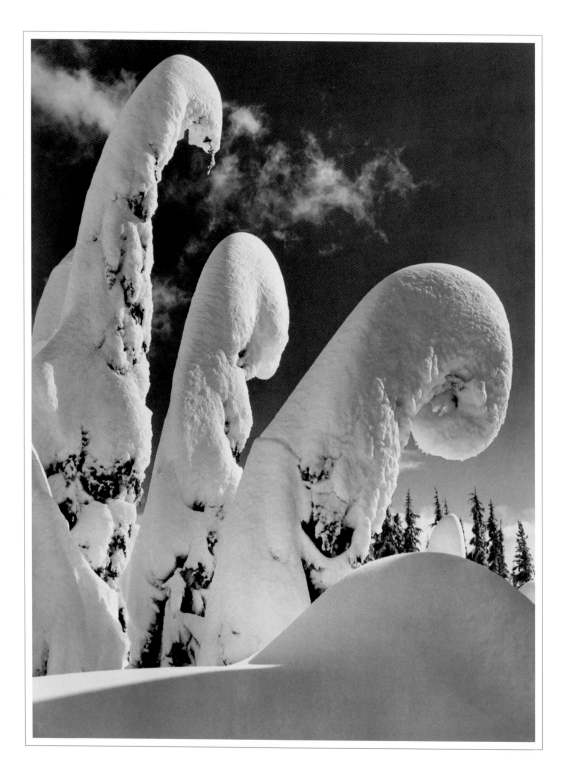

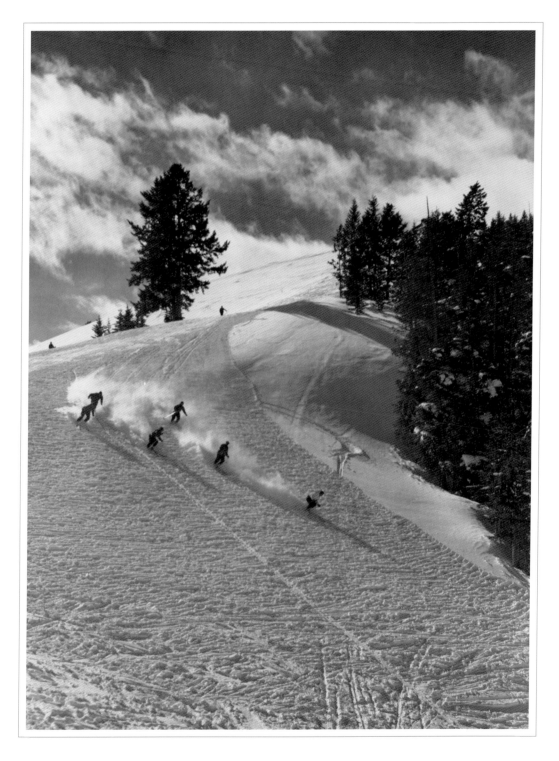

Before the invention of snow-grooming machinery, fresh snow was packed by the ski patrol sidestepping down the hill. This stretch is the Round House corner on Mount Baldy at Sun Valley, Idaho, the only turn you had to make when you were racing for the Diamond Sun. The challenge was a three-thousand-vertical-foot downhill race from the top of Baldy to the bottom of River Run, which you had to complete in less than two and one-half minutes to win your Diamond Sun Medal.

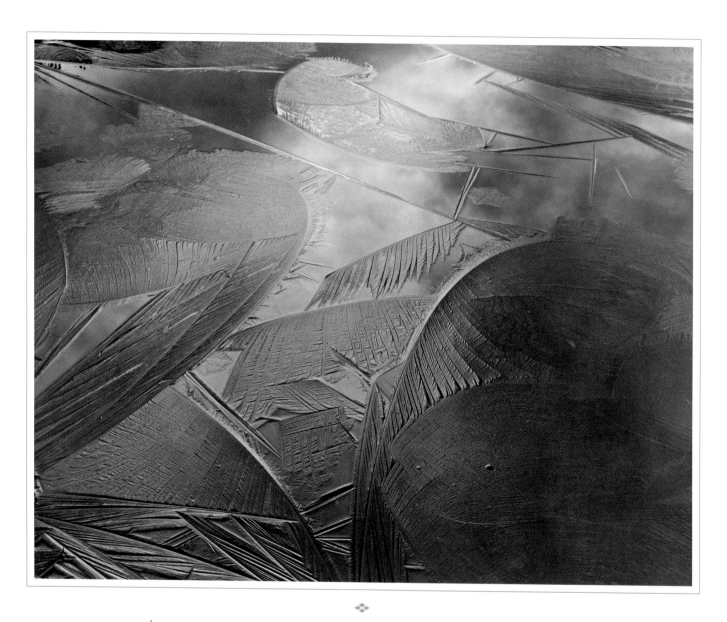

A monochromatic, stained glass window is created by freezing cold air in contact with the icy surface of a high mountain lake before it is covered with snow.

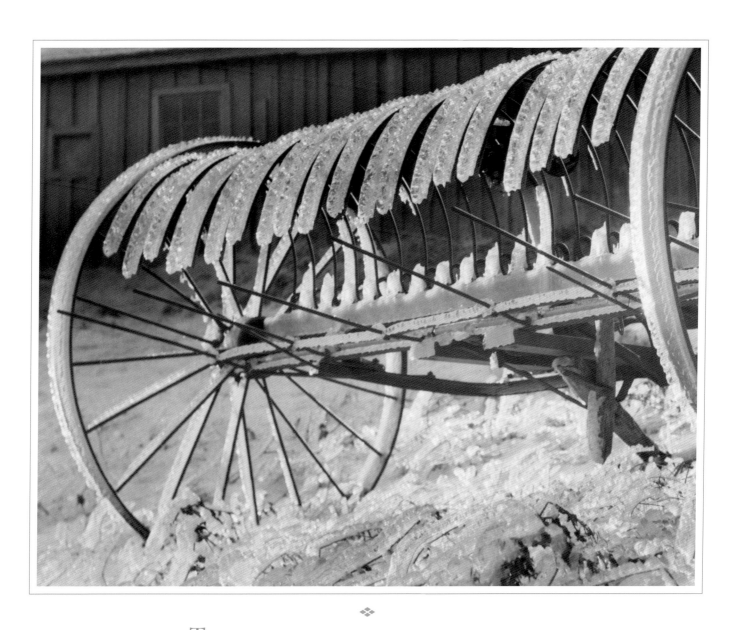

This machine, which appeared in the *Farm Journal* in 1953, might
have inspired the design of early snow grooming machinery.

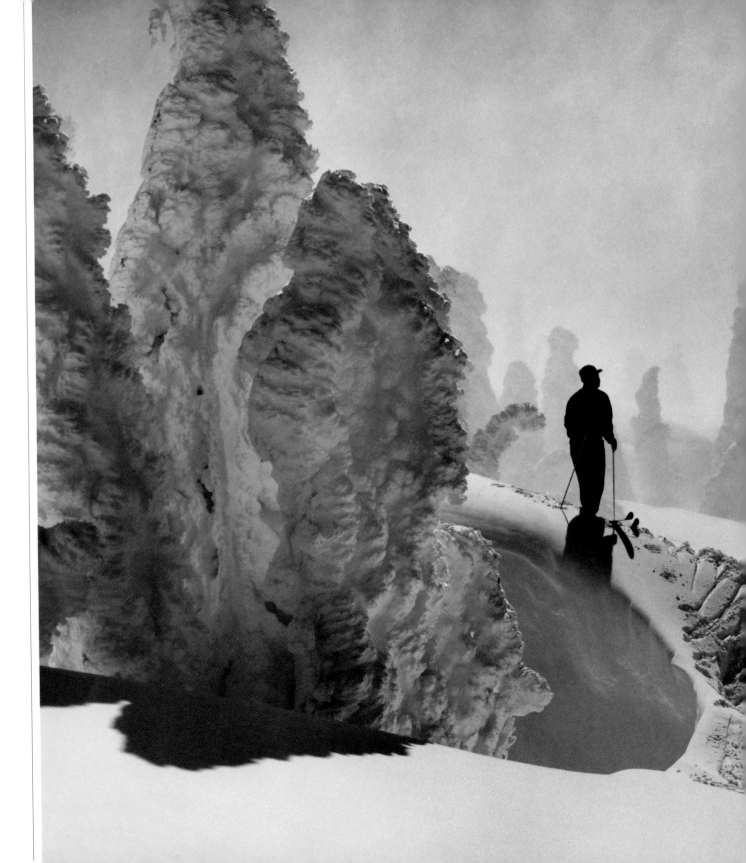

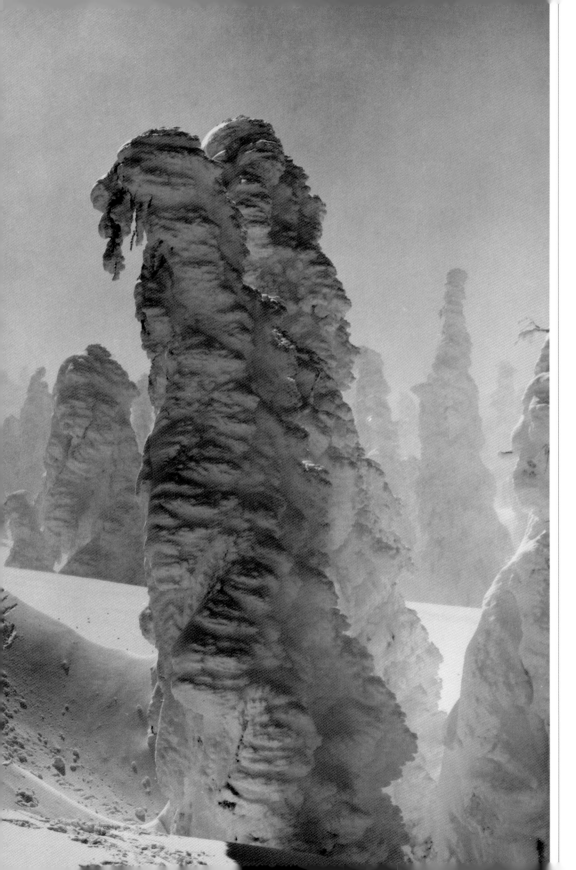

To get better acquainted with the winter monsters of the Northwest, a skier has climbed up for an up-close-and-personal conversation with two of them on Mount Hood in 1949.

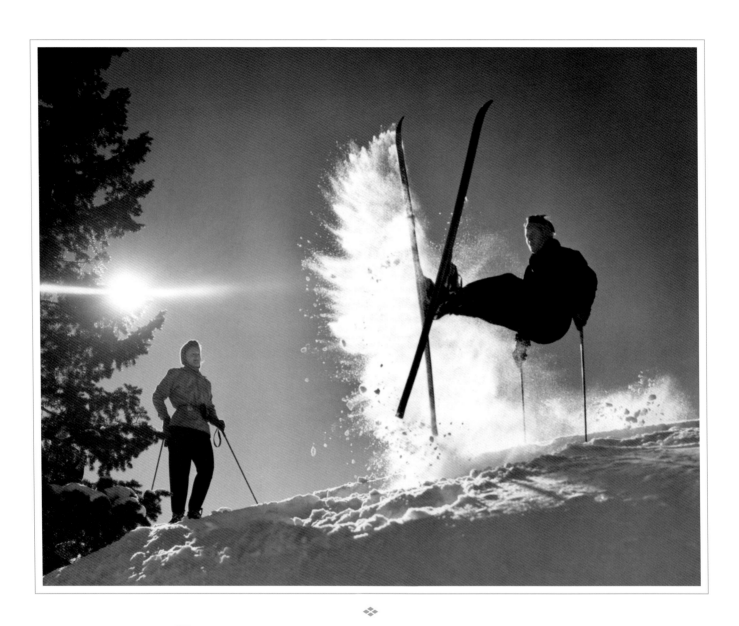

❖

Extreme skiing in 1947 was limited to tricks like this because the long,
stiff skis had no torsional rigidity to make the edges hold, but the bindings
allowed the skis to revolve when you fell even though your leg didn't.

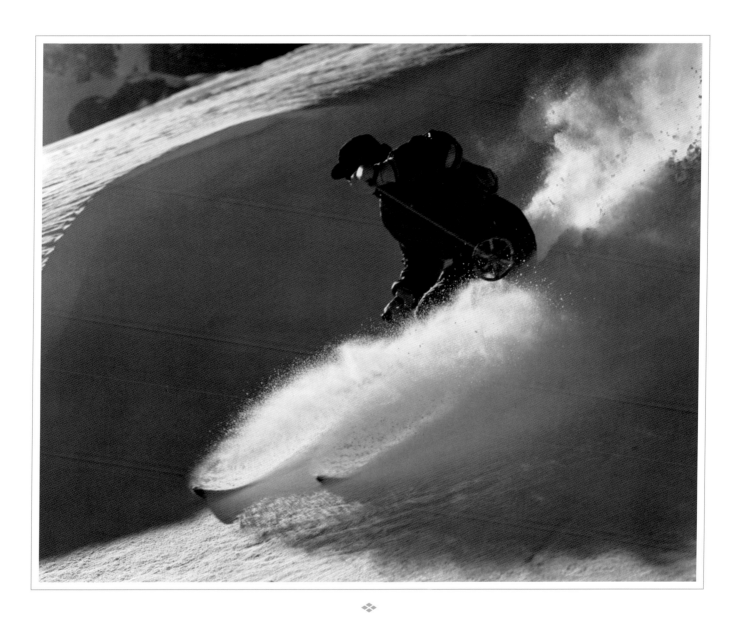

Three-time world champion Emile Allais demonstrates Ray Atkeson's ability to be in exactly the right place to get the just-right, backlit photo. It doesn't matter that Emile's hand is covering his face; the feeling of action is what Ray always got when he clicked his shutter.

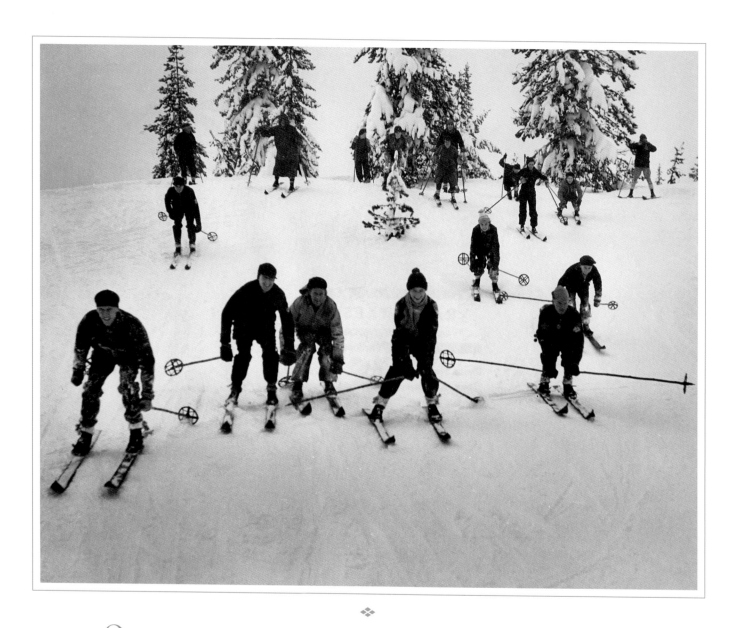

One of Ray's first ski photos was of this group somewhere east of Portland, Oregon. Their equipment and their smiles indicate that this photo was taken in about 1934. Everyone used long, heavy ski poles with six-inch-diameter baskets and wore knee-length, leather hiking boots. The deep crouch technique was for self-preservation so your body was already close to the ground when you fell.

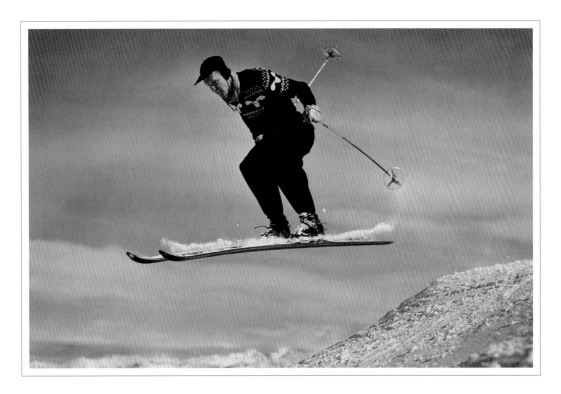

The narrow slot of Ray's focal plane shutter moved from the top of the camera to the bottom, exposing the action as the shutter was moving, which accounts for the bent ski pole in my left hand since the end of the ski pole moved forward while the focal plane shutter was descending.

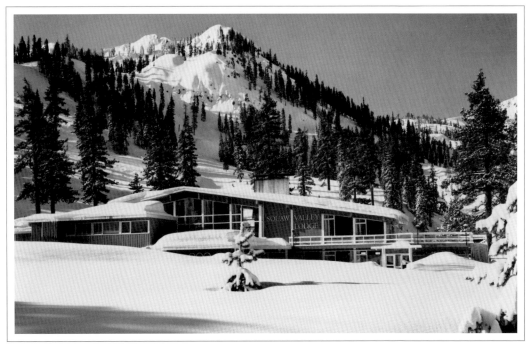

In 1960 Squaw Valley hosted the Winter Olympics, and its television coverage launched the massive growth of new ski resorts all over America during the following decade. The lodge was built in 1949 and burned down in 1954.

At the top of the first chairlift at Heavenly Valley, California, in 1964 skiers sometimes took one look back down the Gun Barrel ski run, took off their skis, and rode back down.

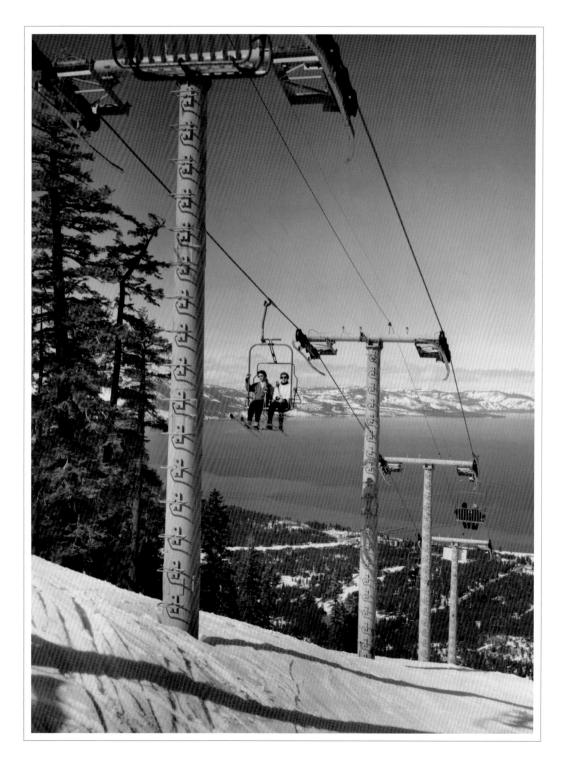

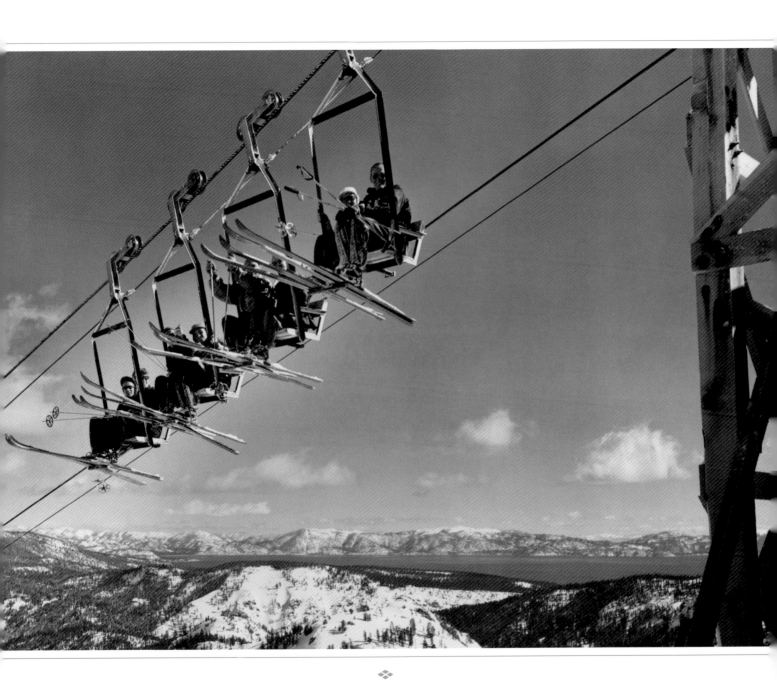

In 1952, Squaw Valley, California, built the only lift of its kind anywhere in the world. While eight people rode slowly up over wooden towers, eight empty chairs went back down just as slowly. With a capacity of less than 150 people per hour, the lift was so inefficient that it was torn down within a year or two.

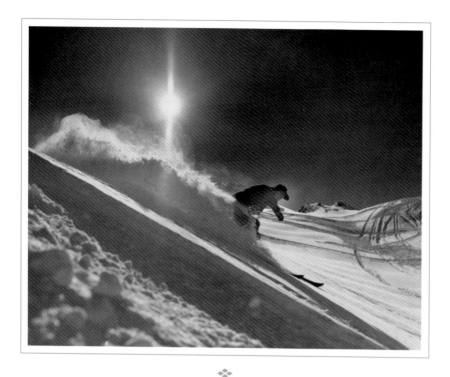

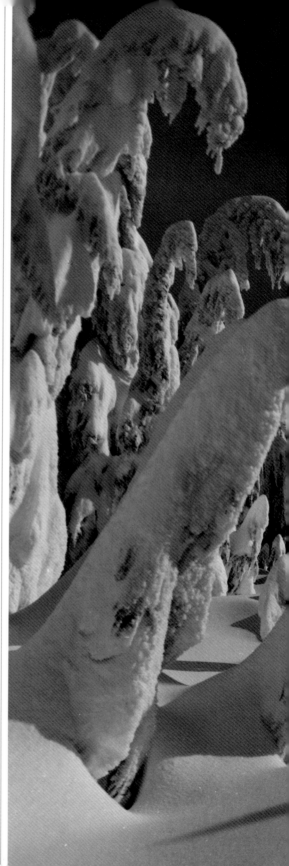

Ray had to be careful when pointing his focal-plane-shuttered Speed Graphic camera at the sun (above) because the focused rays of the sun could quickly burn a hole in the cloth shutter, just as you might have burnt a piece of paper by focusing a magnifying glass on it when you were a kid.

In one of Ray's most famous photographs of Timberline Lodge, Mount Hood, Oregon, the long shadows indicate that Ray was up long before the sun and had skied down to this site, put his camera on a tripod, and waited for the shadows to be just right. He never explained the second set of tracks that joined his, part way down from the lodge. The lights were in the commercial area of the lodge where the staff was getting ready to start the day in February of 1945.

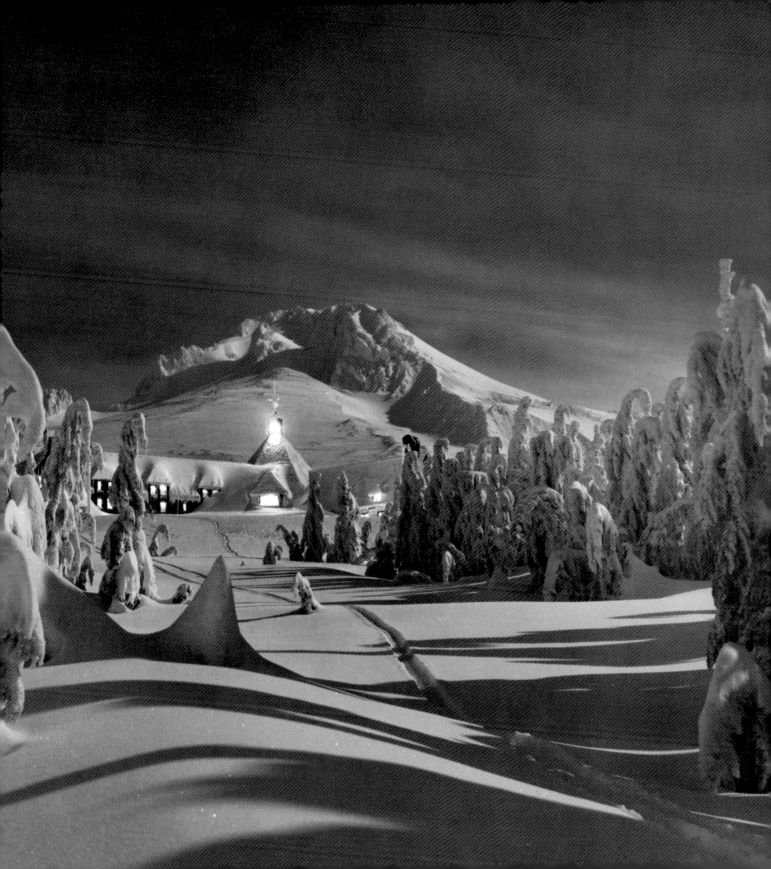

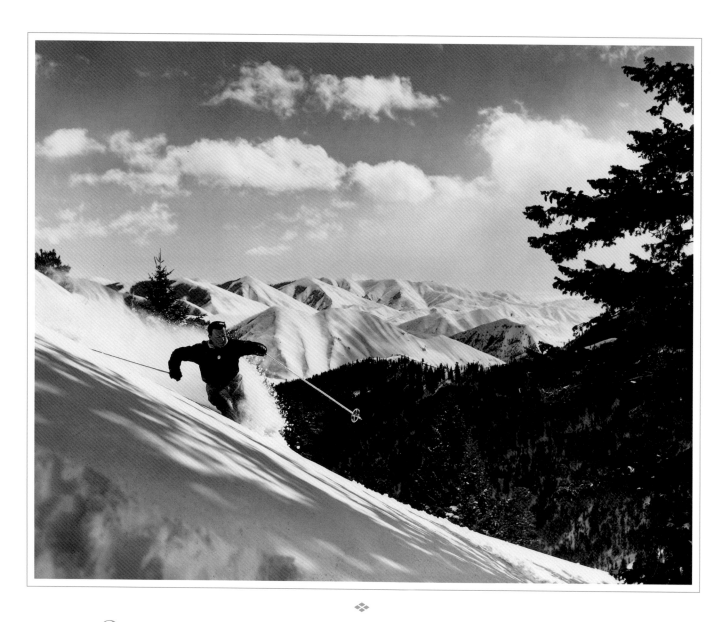

Otto Lang skied in 1947 with style and grace that were decades ahead of other skiers. Otto was the ski school director at Sun Valley, Idaho, when he gave me my first job as a ski instructor in 1948.

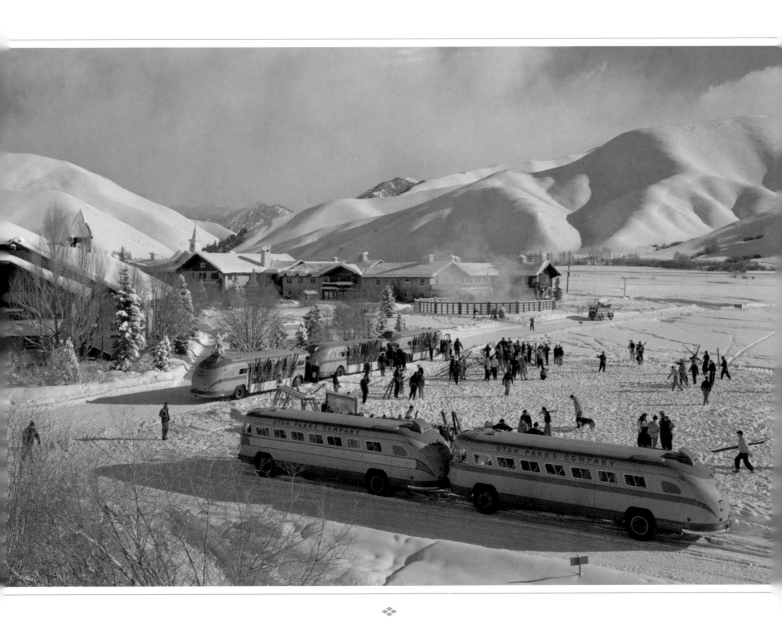

The Sun Valley Ski School's meeting place was in front of the lodge in 1951. Then a learn-to-ski week cost about a hundred dollars, which included room, meals, lessons, and lift ticket. It is 10:00 A.M. and the busses are loaded and ready to drive to Dollar Mountain, site of the world's first chairlift. The Union Pacific Railroad also operated the Utah Parks and brought the busses up from Utah to use at the Valley during the winter. The two busses in the foreground will take the three-mile drive over to Baldy with the advanced classes.

In 1955, Ted Johnson had the reputation of being one of the best powder snow skiers in the world. A few years later he was buying up all of the old mining claims in Little Cottonwood Canyon so he could create Snowbird, Utah. Until Snowbird was finished, all three hotels in Alta depended on septic tanks for their wastewater. Today the Ted Johnson Memorial sewer line runs down Little Cottonwood Canyon and eliminates the septic tank odor that used to permeate every room in every hotel.

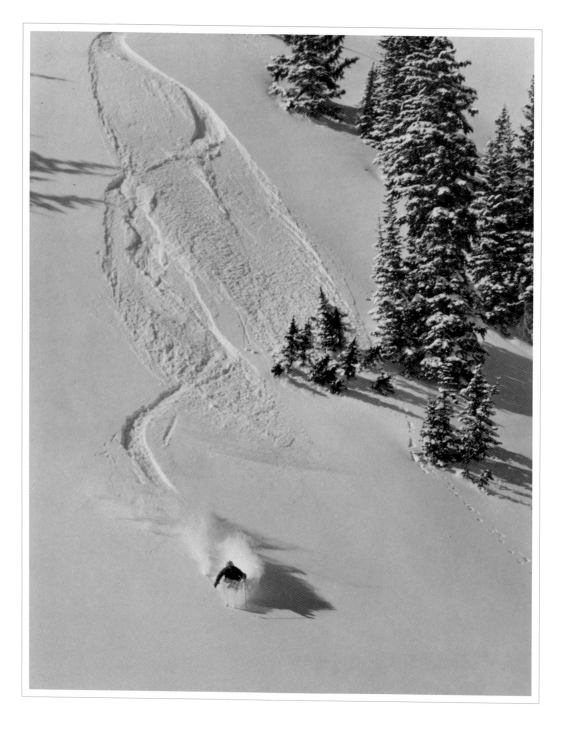

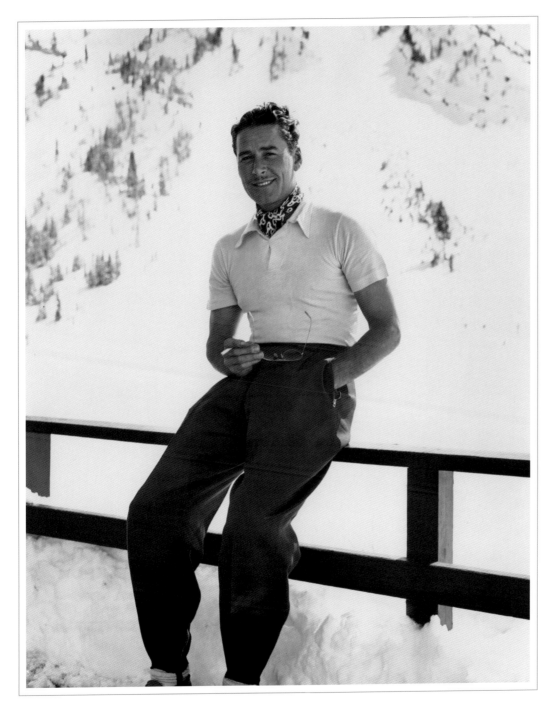

As many people did in 1948, movie actor Errol Flynn took time out from a ski run at Alta, Utah, to have a cigarette.

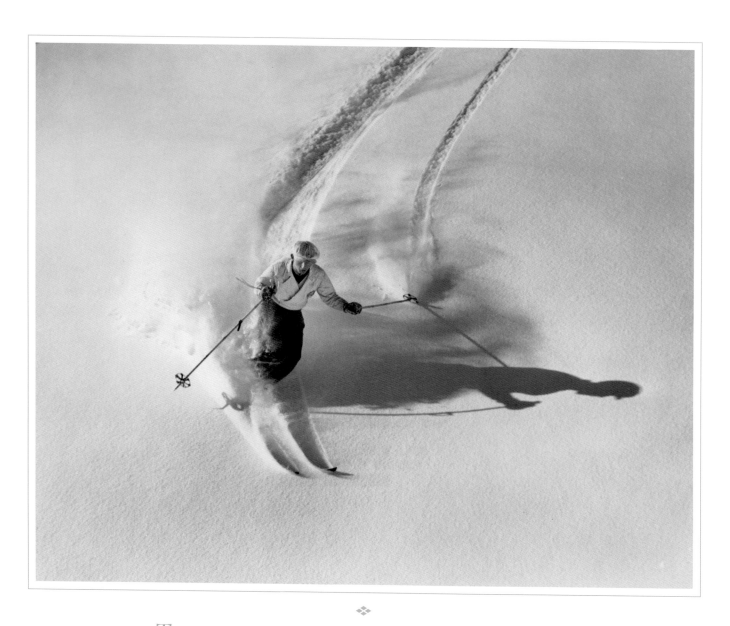

This photo in a magazine in 1946 helped convince me to spend the rest of my life making movies of skiers in untracked powder snow or skiing in it myself.

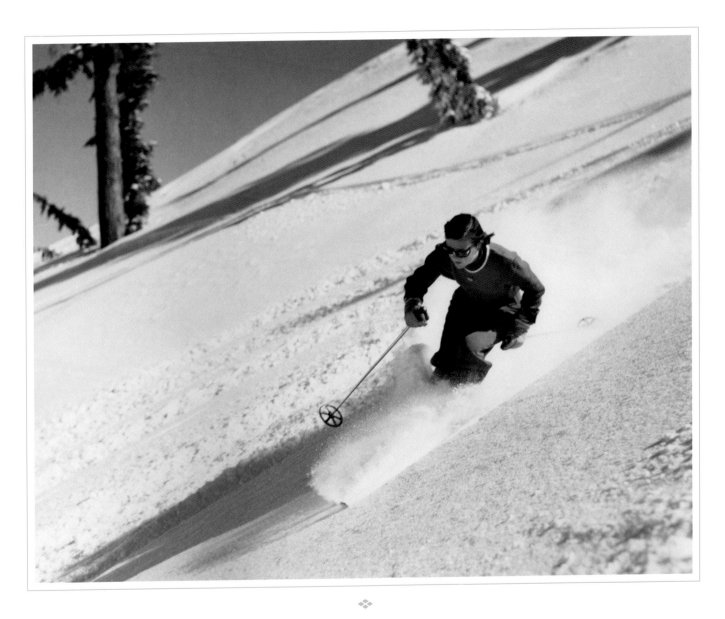

Dodie Post was on the 1948 Olympic ski team and was one of three instructors I taught with at Squaw Valley, California, during the winter of 1949–50. Dodie retired from teaching skiing when she married author Ernest Gann.

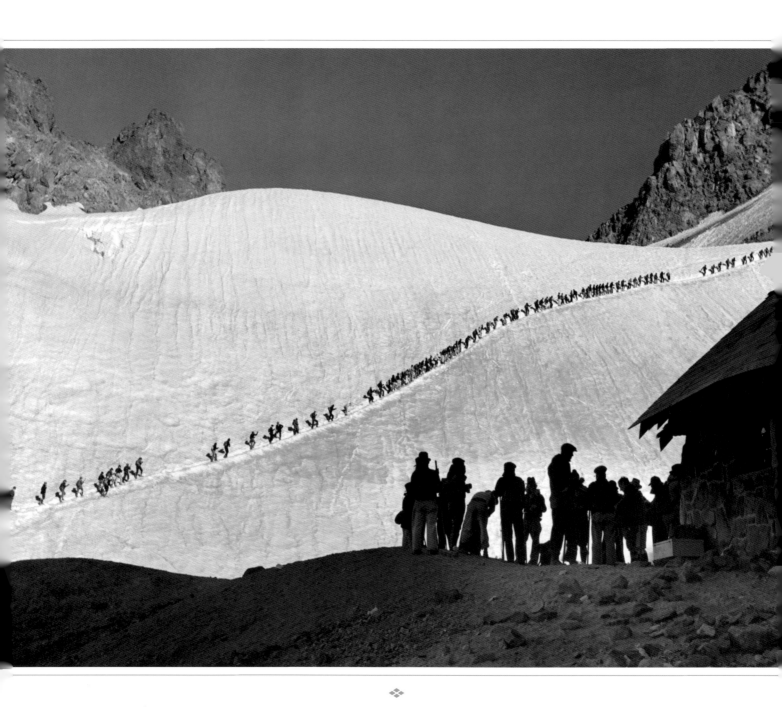

And you complain about the occasional ski lift line? This is Mount Hood on a summer day in 1939.
Mount Hood has the reputation of being one of the most climbed high mountains in America.

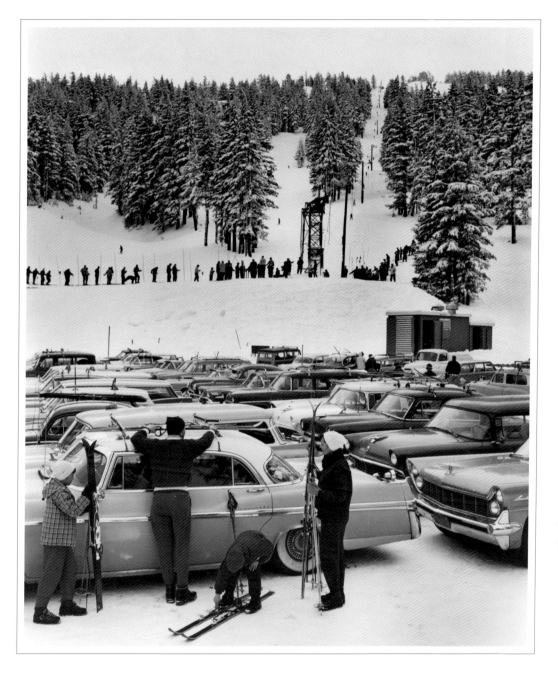

Because it is farther from the ocean than any other Northwest coastal ski resort, Mount Bachelor near Bend, Oregon, offered excellent dry snow conditions to attract skiers from other resorts in 1958. They stood in line for up to half an hour to ride its one Poma lift, its rope tows, or its one chairlift. The parking lot is full of new 1957 Chevys and Fords that then cost $1500. Today they would be worth $15,000 if anyone had kept them instead of trading them in for a 1958 model.

At Mount Rose, Nevada, almost everyone got off the T-bar half way up the hill because the upper part of the mountain was too steep for them to ski in powder snow.

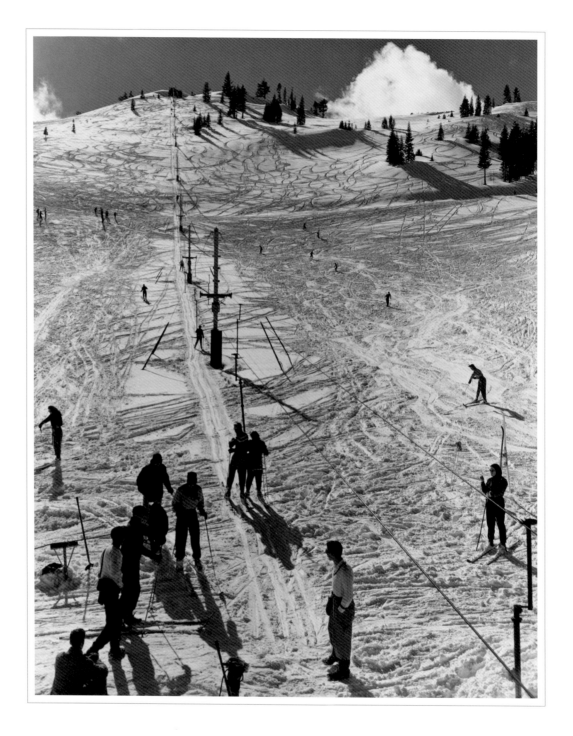

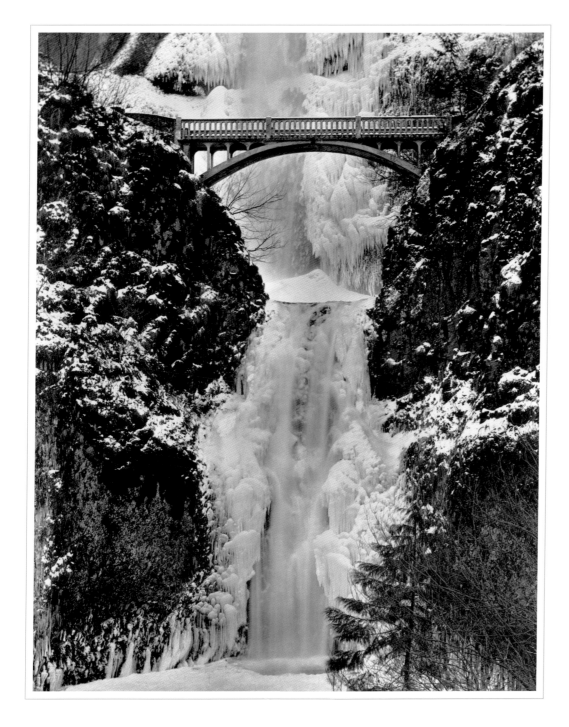

Near Portland, Oregon, Multnomah Falls when frozen are testimony to the power of nature when it gets cold enough. Up until the year 2000, no extreme skier or snowboarder has tried to make turns here for the cameras and glory.

Slalom racing
equipment has changed
a great deal since 1952.
Jack Reddish is trying
to turn skis that are
seven foot six inches
long in the Harriman
Cup Slalom on Rudd
Mountain at Sun Valley,
Idaho. Jack was on the
1948 U.S. Olympic
ski team, and during
his career he won
the National Slalom
Championship by more
than three seconds.
Today, most slalom races
are usually won by
hundredths of a second,
and three seconds will
separate the first thirty
or more racers.

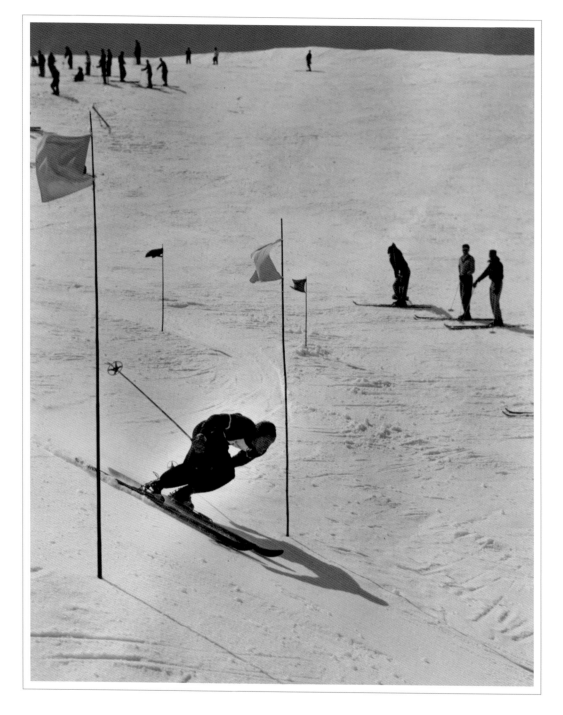

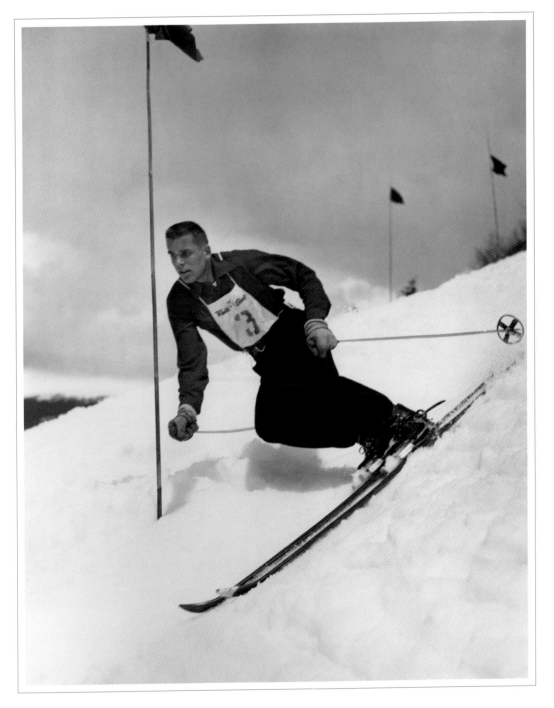

For many years, sportswear-maker White Stag supplied bibs for ski racers all over the West. It was the first company to realize the value of on-slope marketing. Based in Portland, Oregon, the owner, Harold Hirsch, learned to ski on Mount Hood when he was in college in 1933. Racer Carl Fullman's beartrap bindings were the only ski bindings available in the 1940s. This was before the invention of release bindings that allow you to fall and not break your leg.

Ski schools used to insist on final form, as demonstrated by former Squaw Valley, California, Ski School director, Stan Tomlinson and Pierre Jalbert, who are making almost identical parallel French technique turns.

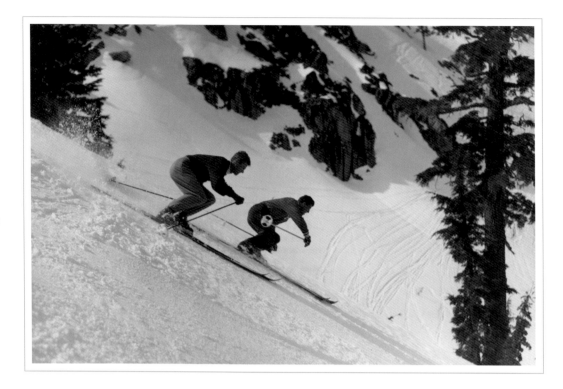

Most 1940s ski resorts were built with very little money and a lot of hard work. As a way of cutting costs, they often built the lift towers out of trees that had been cut down nearby to make the trails.

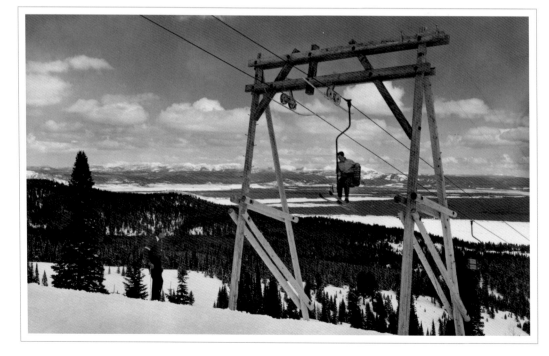

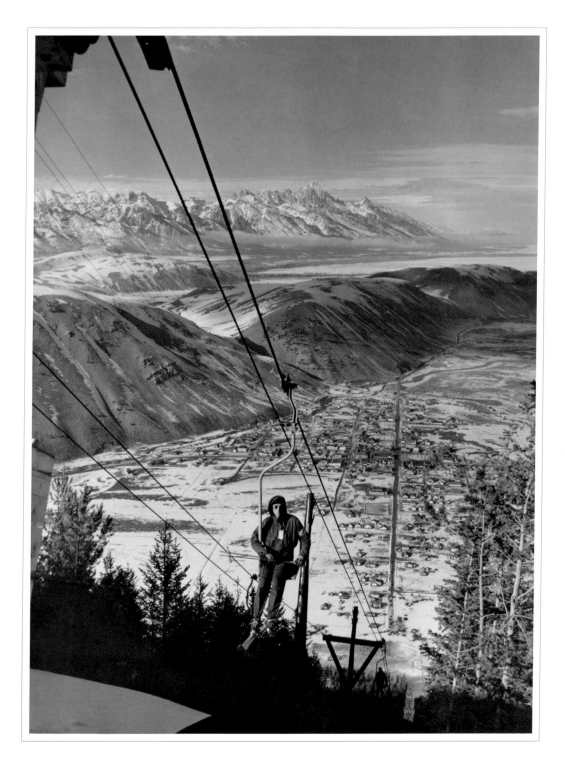

In 1948 Jackson Hole, Wyoming, had just one chairlift right next to town on Storm Mountain. It was built with a fixed cable for the metal sheaves that the chair hung from, and below it a moving endless cable that hauled the chairs up the hill. This design for a chairlift was copied from mining lifts that transported gold or silver ore where roads were too expensive to build.

When Sun Valley was being built in 1936, the publicity agent Steve Hannigan said, "You have to build a swimming pool so people won't think that skiing is too cold. And while you're at it, make it a round one so we can get a lot more free publicity with photographs of it." It became the most photographed swimming pool in the world.

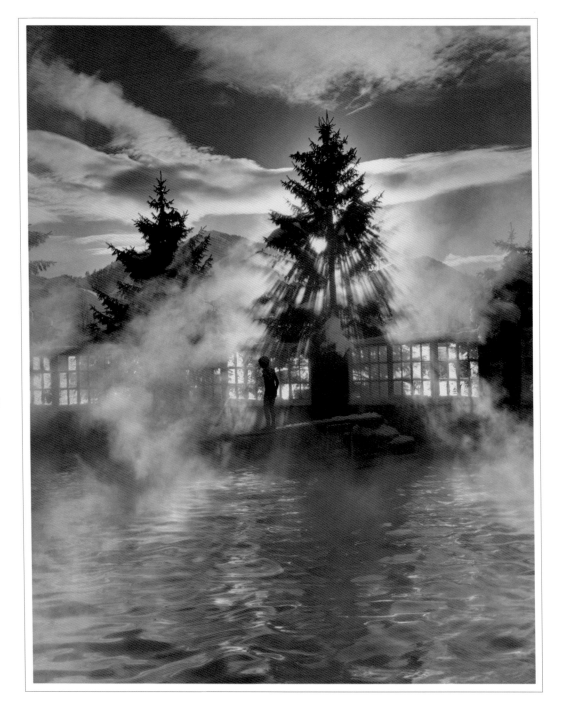

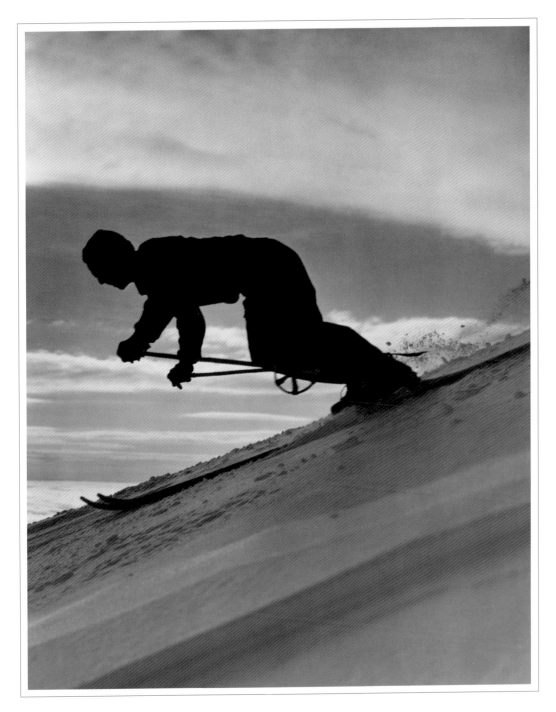

In the 1940s, extreme forward lean was necessary because the tips of laminated wooden skis twisted away from the side of the hill and wouldn't hang on to hard snow. A carved turn was something everyone tried to do, but the equipment wouldn't let them do it. This skier is Willie Helmig at Mount Hood, Oregon.

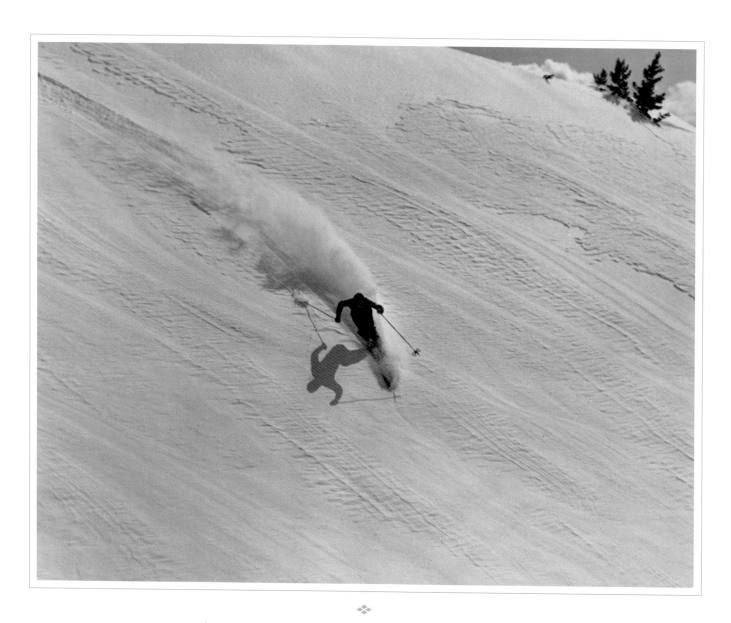

❖

Anywhere in Montana in the late 1940s was a nearly deserted
place to ski. The same is true today because the city of Bozeman,
Montana, has less population than Vail Valley.

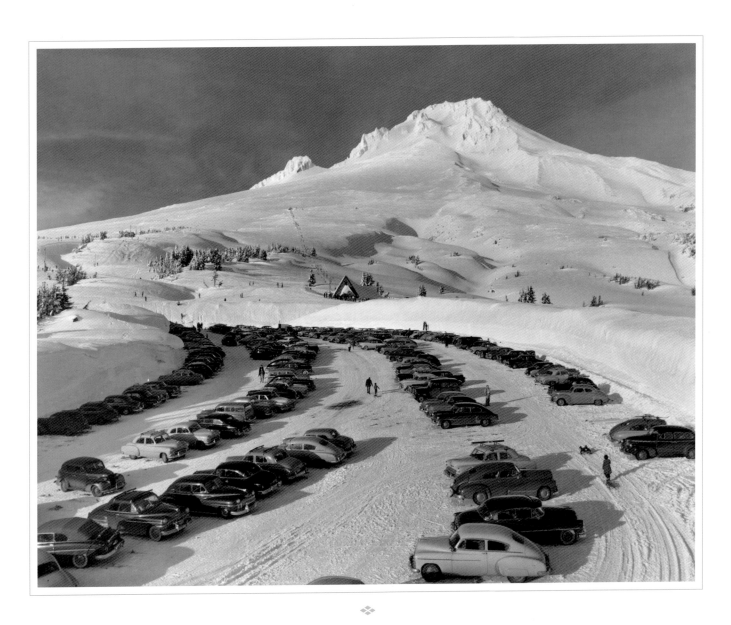

At Mount Hood in 1948 when the Magic Mile chairlift was in full operation, there would be only three or four station wagons in the parking lot. Today there would only be three or four sedans in the parking lot.

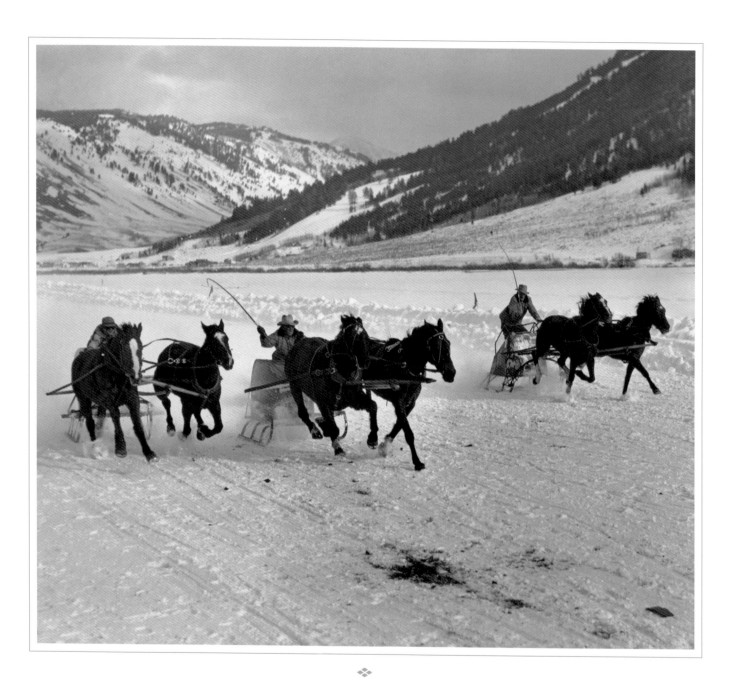

Men have raced in chariots since ancient Roman times. When men race speedy quarter horses at below-zero temperatures in Jackson Hole, Wyoming, they have been known to bet the farm on the outcome of a single race.

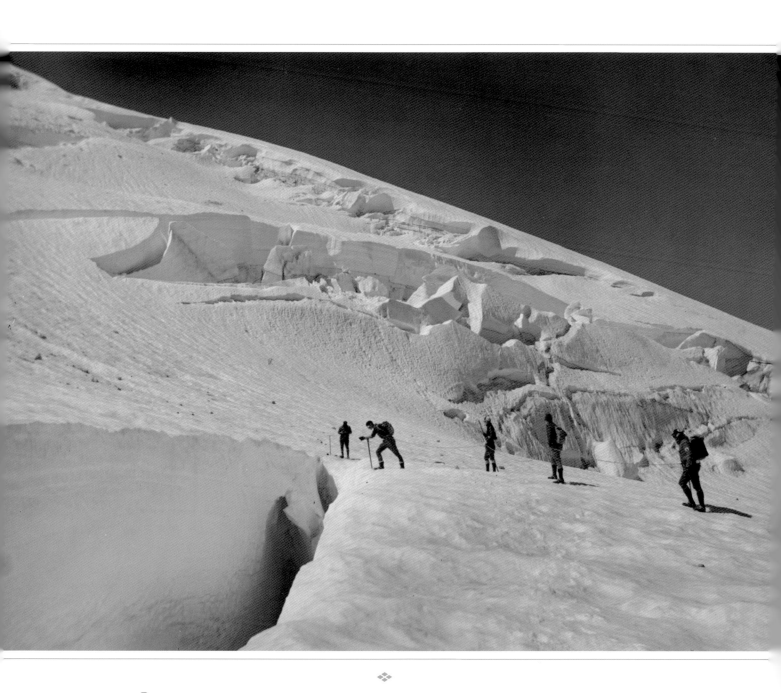

In 1933 Ray captured this shot of someone standing dangerously close to a crevasse on the Eliot Glacier on Mount Hood, Oregon. Almost seventy years ago Ray had already started moving away from the standard camera angles used by other photographers.

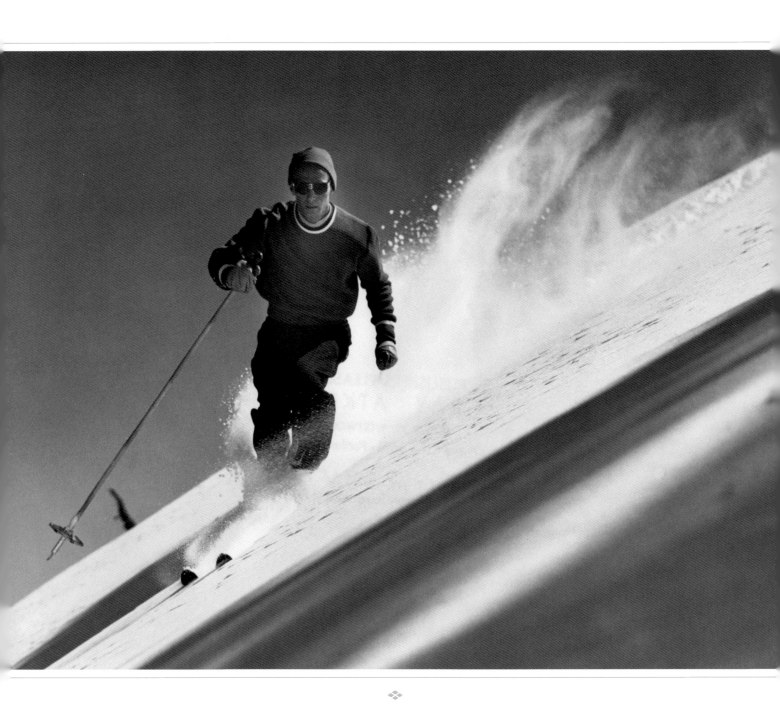

By 1952, skiers were starting to realize that Howard Head's invention of the metal ski made powder snow much easier to turn skis in. This powder snow was at Squaw Valley, California.

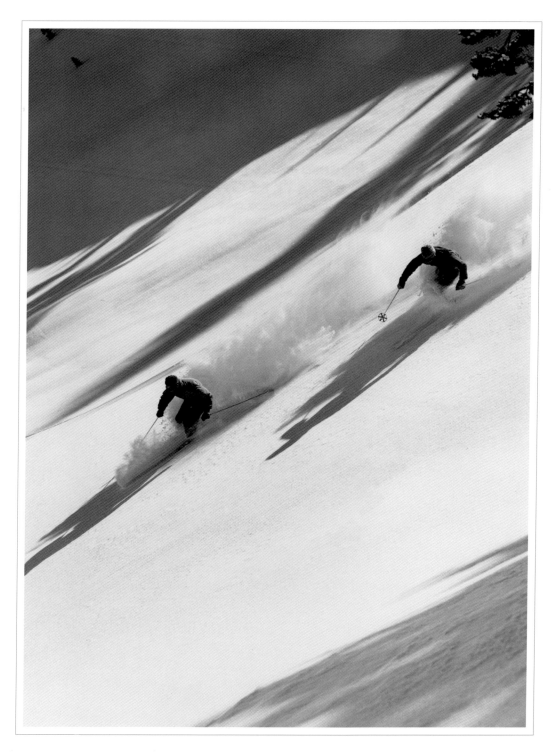

Two of the former ski school directors of Squaw Valley, Stan Tomlinson and Joe Marrilac, demonstrate identical French Technique turns.

You could ski at Alta, Utah, in the late 1940s in deep, untracked powder snow from one storm until the next. Alta only had two very slow single chairlifts to ride at the time, but an all-day lift ticket cost two dollars and fifty cents, so the high cost of skiing kept the lift lines to a minimum.

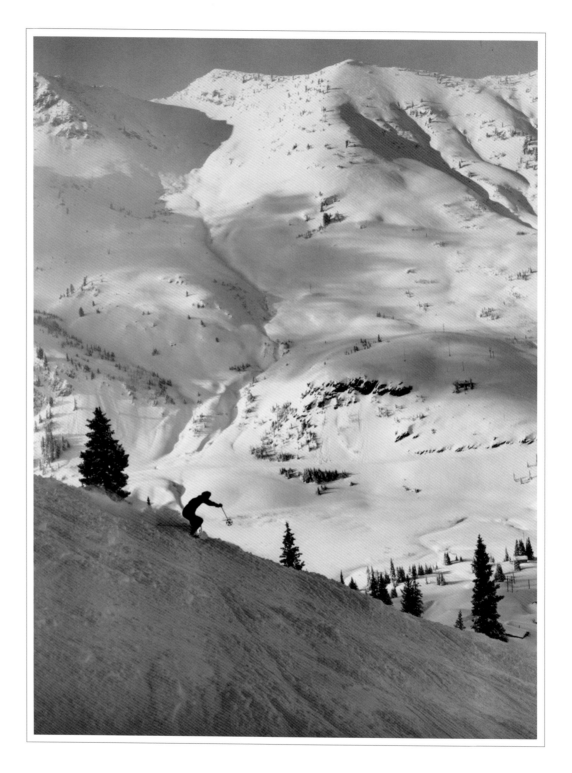

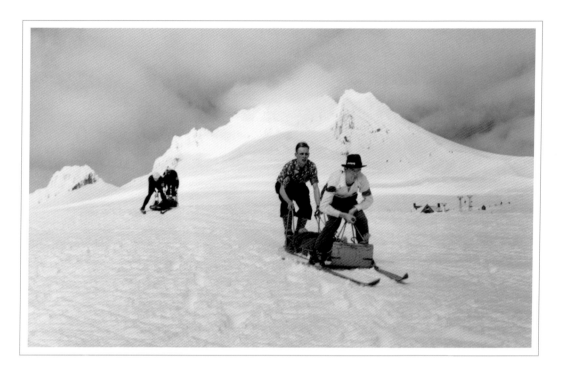

In 1947 a ski patrol toboggan didn't yet have the long front handles. One patrolman stood on the back so he could brake, and the other one skied in front and hoped that five-hundred pounds of toboggan, patient, and assistant wouldn't run over him.

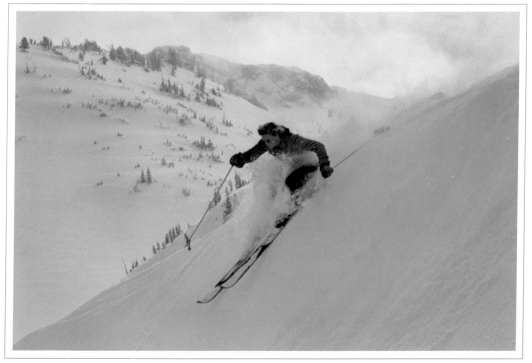

In 1939, five-foot-four-inch-tall Betty Woolsey was carving turns in Alta, Utah, powder on seven-foot-six-inch stiff hickory skis.

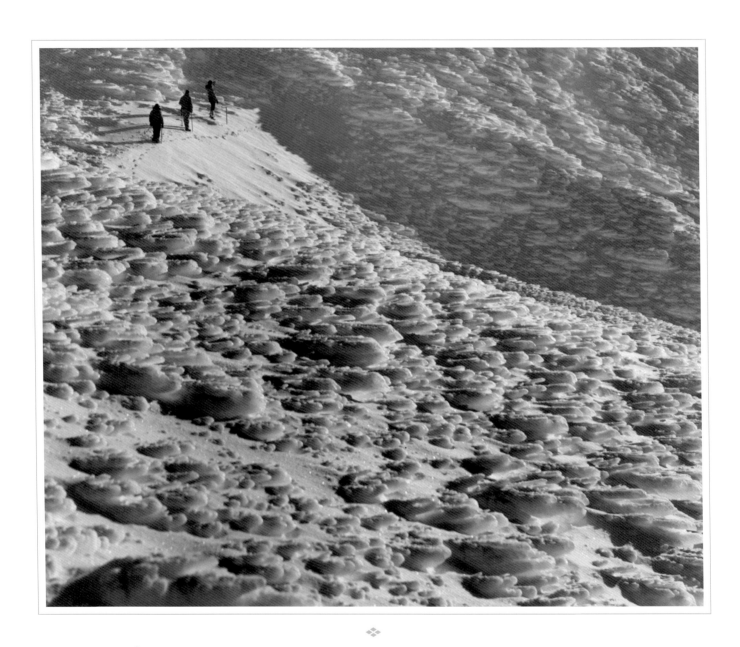

And you complain when there is not enough powder snow to make tracks? Try skiing in this kind of wind-blown-frozen-hard-as-a-rock sleet. This picture was taken near the summit of Mount Hood in 1939, and fortunately this trio is hiking and not planning on trying to ski down.

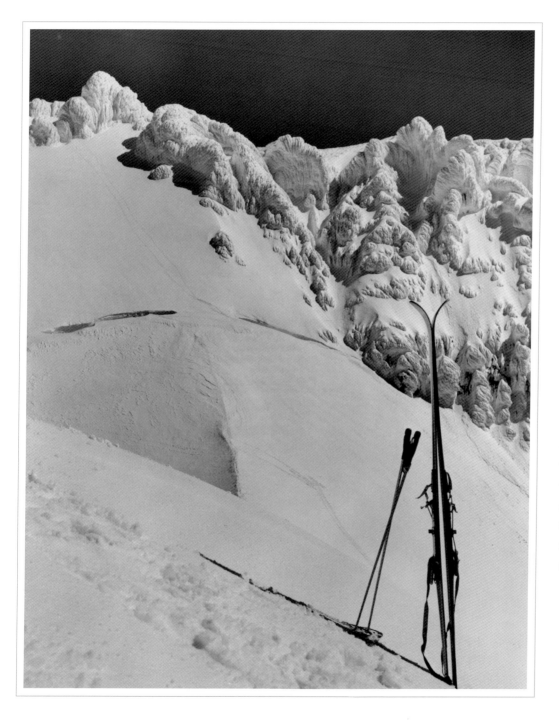

The same group of four skiers made the two sets of tracks on The Chute at the summit of Mount Hood in Oregon. They climbed up in the early morning, took one look back down the steep headwall, changed their minds, and carefully climbed back down. In 1954 there was only a handful of skiers who could even think of skiing anything this steep. One of them whose skis you see in the foreground was smart enough to be using Hjalmar Hvam's revolutionary new safety bindings.

In the 1940s you could build a ski resort for the cost of the rope, an old automobile engine, and about a dozen automobile wheels for the rope to run on. Estimated cost was less than five hundred dollars and a lot of sweat. Many of those small resorts produced the Olympic champions of the 1960s and '70s. Unfortunately, many of these areas have been forced to shut down by the emergence of the destination ski resort with all of its high-budget amenities. Fortunately this small rope tow hill is still running today, almost sixty years later, near Yellowstone.

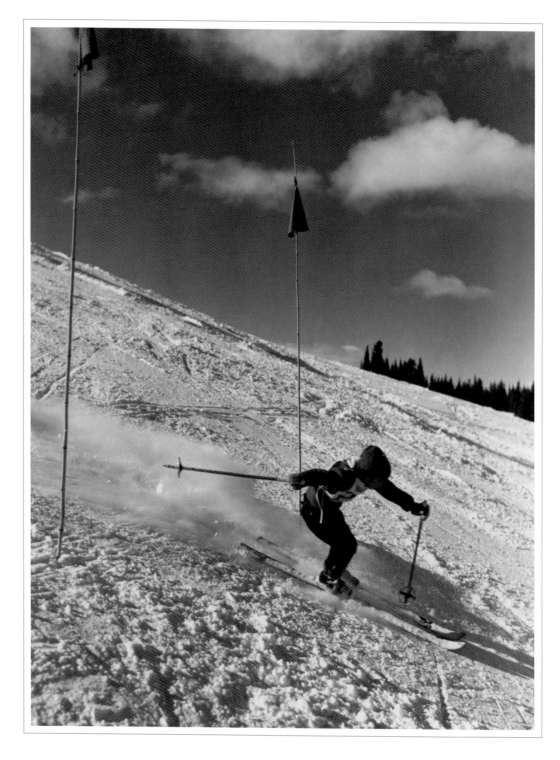

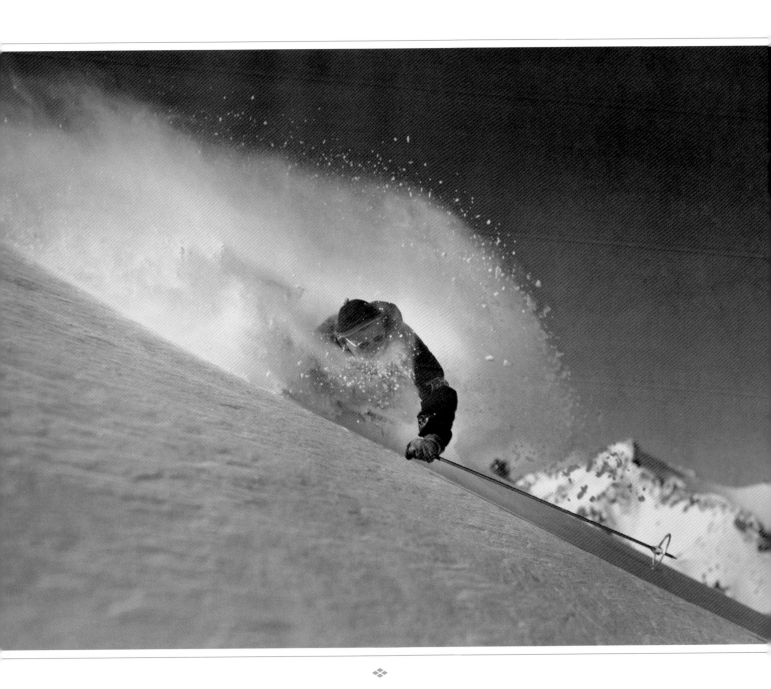

Ski school director Alf Engen at Alta, Utah, was a master of powder skiing. In 1952 a
lot of upper body motion was necessary to turn the long, stiff skis in deep snow. At one
time Alf was the national champion in downhill, slalom, cross-country, and jumping.

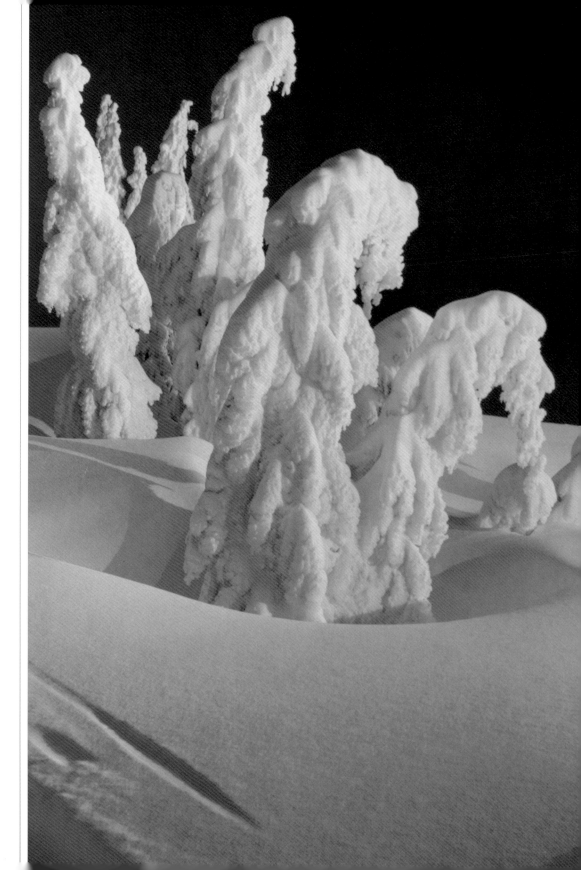

Someone has made tracks off into the night to get to a party in a nearby cabin somewhere in the Northwest.

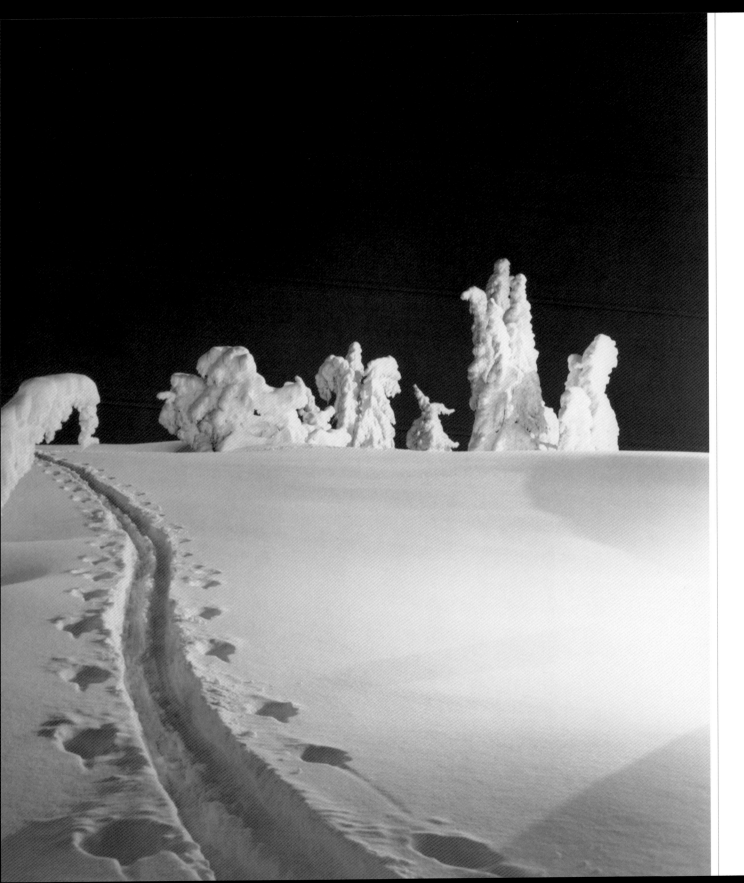

These skiers have left their tracks high up on Eliot Glacier after a four-hour climb in the middle of July in 1948. To ski in this kind of corn snow, they started climbing in the predawn darkness to get to the top at just the right time. Corn snow is one of the most delightful kinds of snow for leaving your tracks on the mountain and memories in your brain.

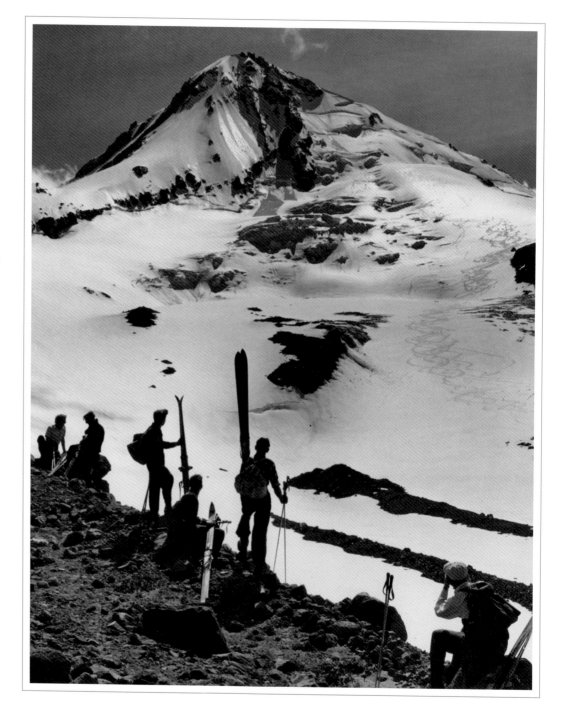

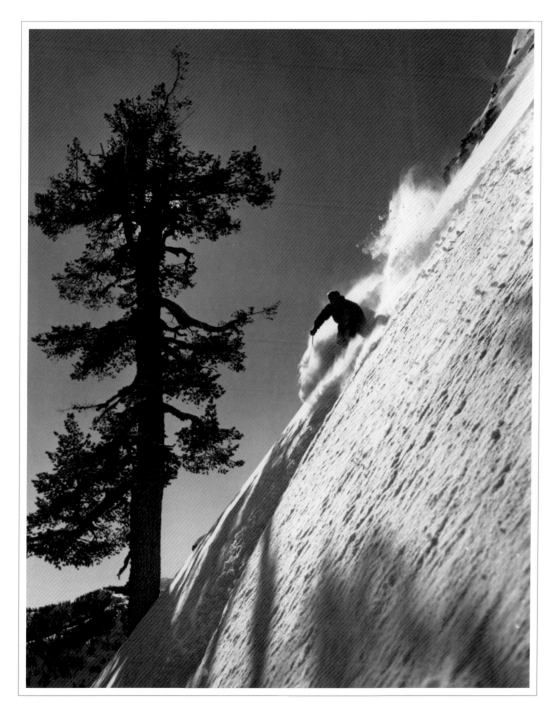

Ray almost never took a picture with his camera pointed up the hill. Across the hill was his favorite direction to emphasize the steepness of the slope. His subject here, in 1952, is Joe Marrilac, former ski school director at Squaw Valley, California.

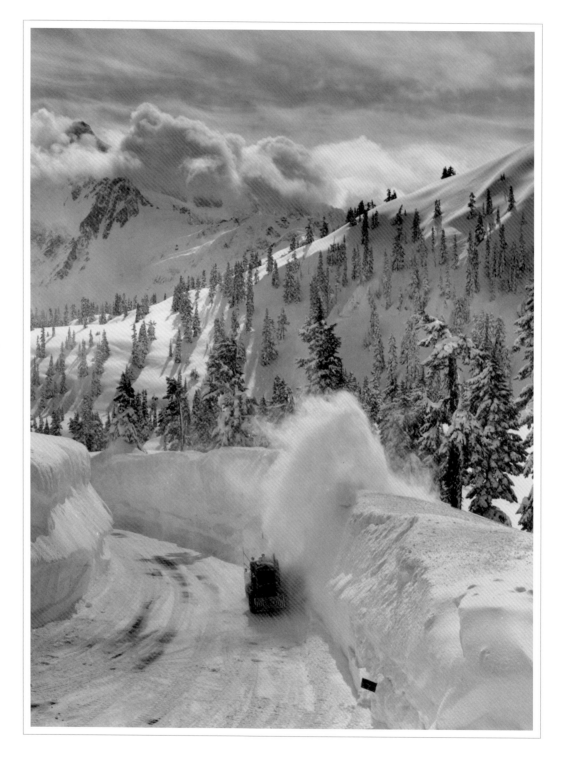

The roar of two giant diesel engines was the sound of a clear road to your favorite ski resort. It took a lot of horsepower to throw massive amounts of snow high enough to land on the top of already forty-foot-high snowbanks on the highway to Mount Baker, Washington, in 1949.

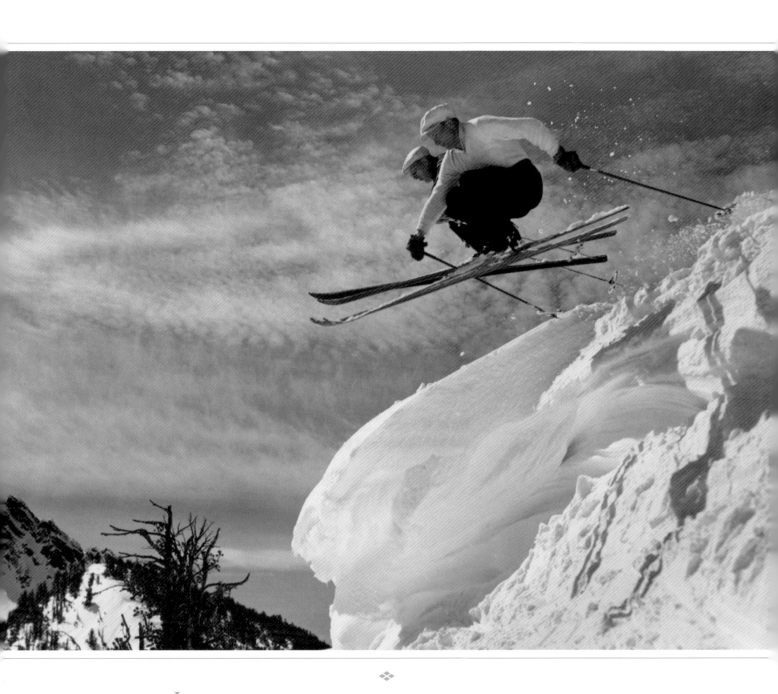

If one jumper makes a good commercial picture, Ray knew he could sell more copies of two jumpers doing the same thing. This 1944 shot of "extreme" skiers of the day convinced a lot of testosterone-charged young men to take up the sport.

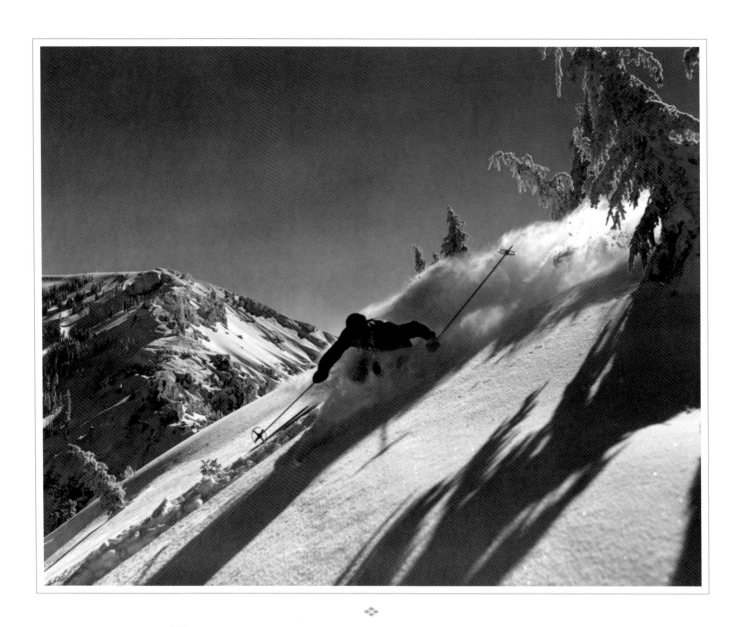

The smooth style and technical expertise of Bill Klein, the ski school director at Sugar Bowl, California, changed the lives of thousands of pupils while he taught them about the freedom that can be found on a pair of skis.

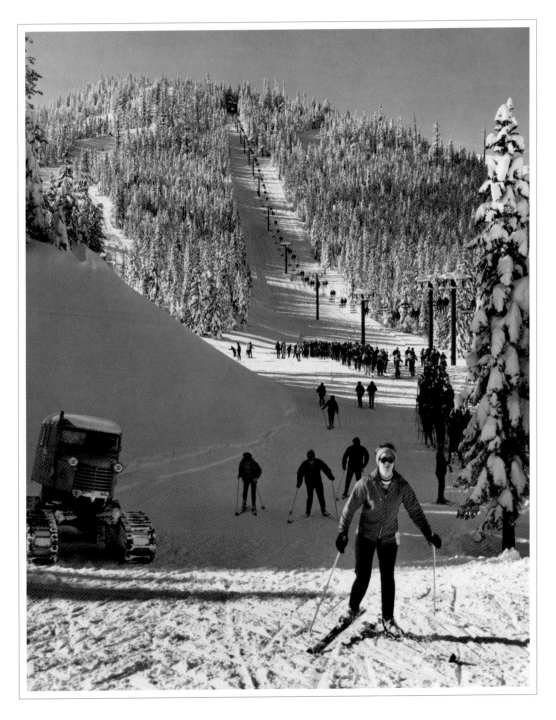

The Multipor ski area on Mount Hood, Oregon, had a double chairlift before they had cut enough trails to handle all of the people waiting in the lift line. The Tucker Snowcat in the foreground was 1950s pioneer snow compaction machinery and was designed and manufactured in Medford, Oregon.

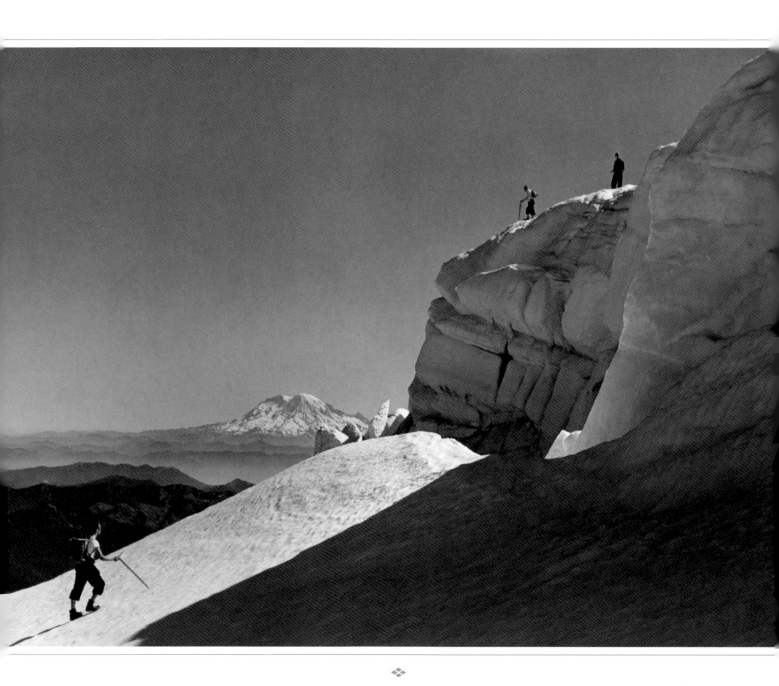

In the 1930s, men and women were content to climb up on top of ice blocks and just look down and have their picture taken. Today they climb up and jump off on skis or snowboards for movie cameras.

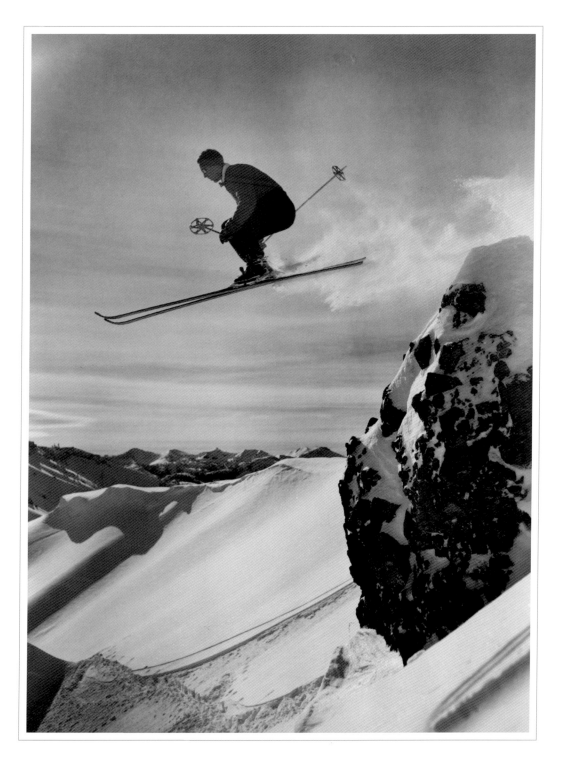

In 1949, Ray caught Jerry Hiatt in the middle of an extreme jump at Sugar Bowl in California.

Extreme skier Dave Quinney, in the 1940s, tracks up the powder snow at Alta, Utah. Dave's father supplied some of the original money that built the first two chairlifts at Alta for a rumored ten thousand dollars. The lift towers were made of used telephone poles, and the lift cables came from an abandoned gold mine.

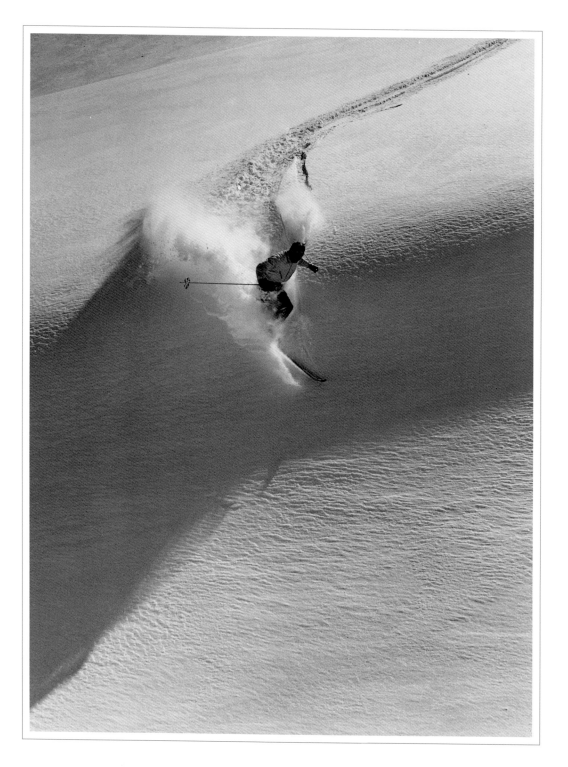

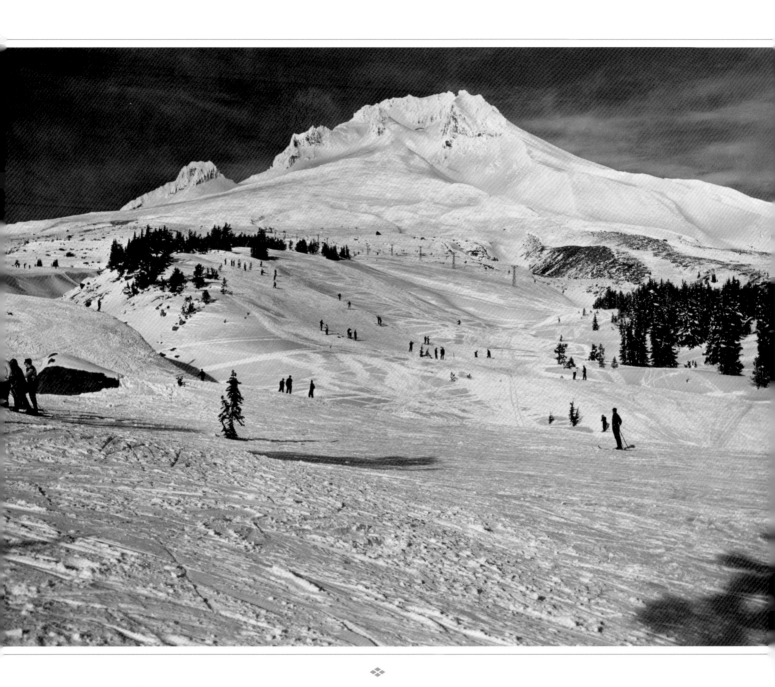

On the first weekend of the 1949 season at Mount Hood, Oregon, the Magic Mile chairlift
was running and none of the smaller valleys had been blown full of snow yet. In those days,
many skiers used to climb to get in shape and to save the four-dollar cost of the chairlift ticket.

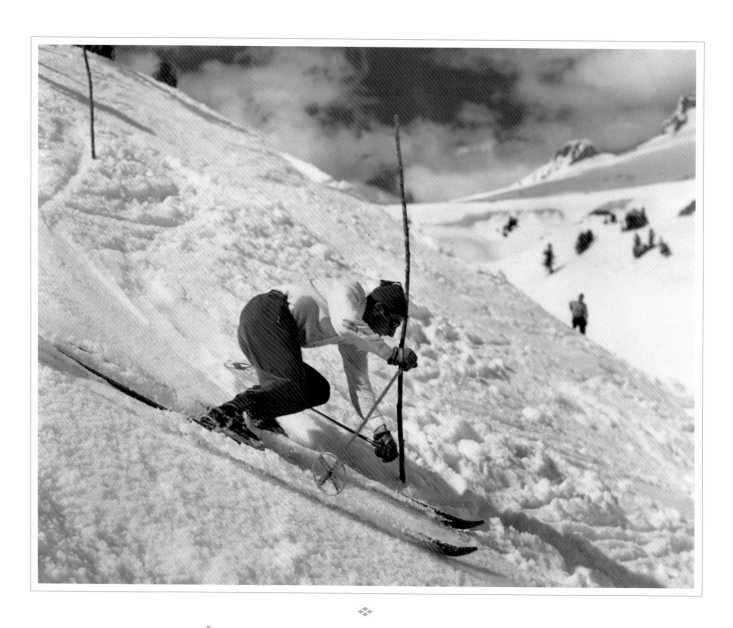

In the 1950s you had to race through slalom gates made of
stout saplings on seven-foot-six-inch skis while using heavy ski
poles that had baskets the size of a seven-and-a-half hat.

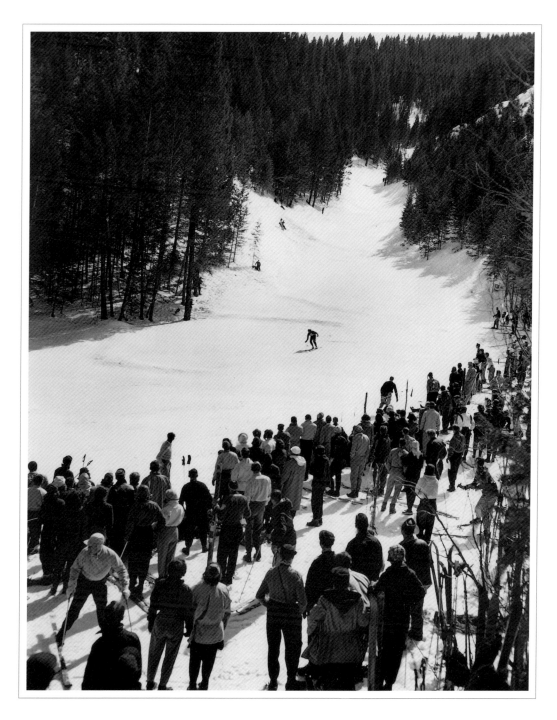

Warm Springs at Sun Valley, Idaho, before the chairlifts, was the site of the 1952 Harriman Cup downhill. Very few control gates were necessary for the race, because the trail was so narrow you had to make a lot of turns to miss the trees.

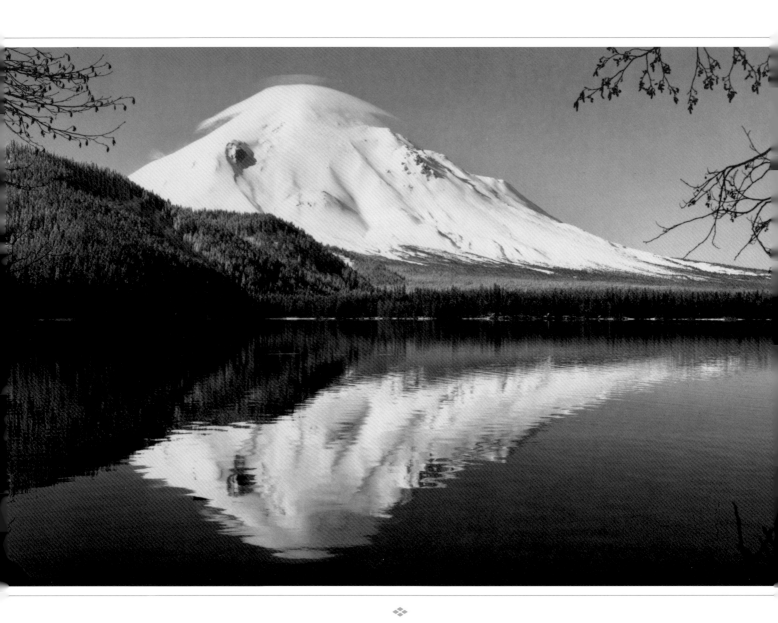

Mount Saint Helens stands taller in the winter, many years before the famous eruption that completely filled Spirit Lake with ashes and debris. Ray had to hike many miles to get to the lake in 1943 because there was almost no reason to plow the road in the winter.

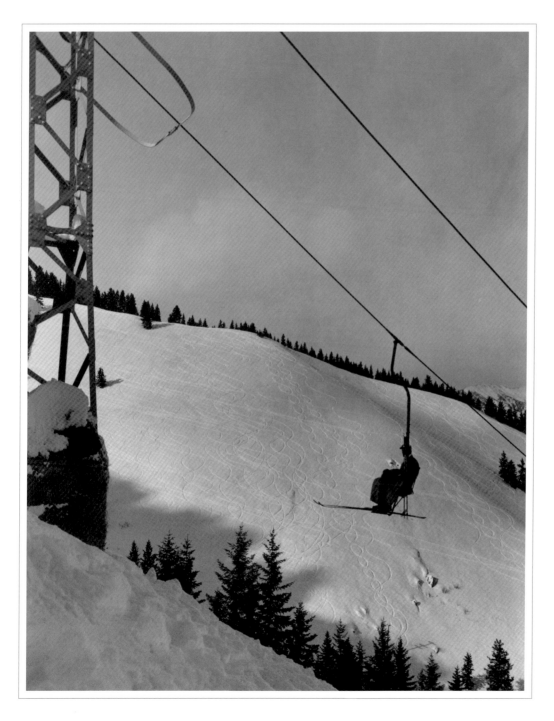

After a big snowfall, these south slopes at Sun Valley, Idaho, have always been the perfect hill to leave your tracks. Then, when you rode back up the Exhibition lift in 1948, snuggled down against the cold under the attached blanket, you could look over and say, "Hey, those tracks were made by me and—" then you could fill in your skiing friend's name.

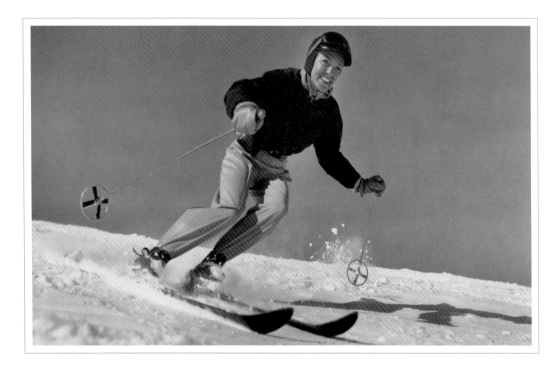

Blanche Hauserman carves a turn on this perfect, packed-powder day at Sun Valley, Idaho, in 1947. She is wearing seven-foot skis, which were about the shortest ski you could buy at that time.

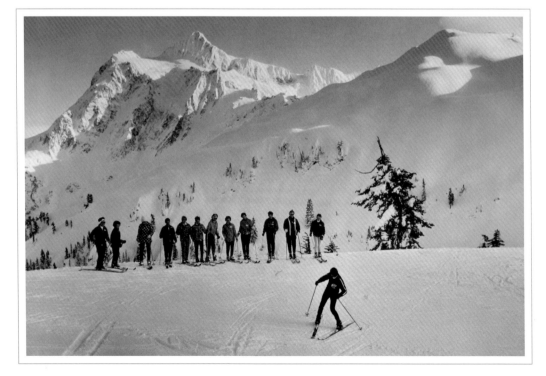

Twelve pupils in the Mount Baker ski school in Washington are being taught the finer points of what makes a ski turn in 1959. During the winter of 1999, over one hundred feet of snow fell here, the deepest snowfall ever officially recorded in one winter anywhere in the world.

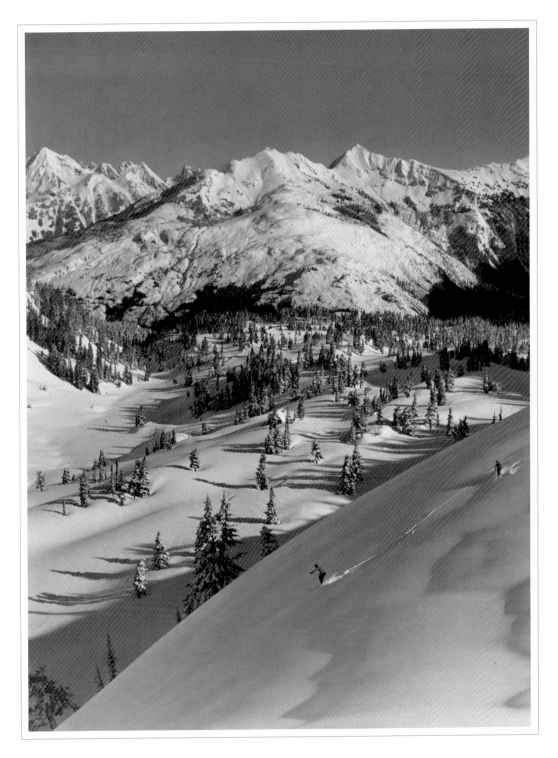

Unlike skiing fifty years ago, to ski in snow such as this (at Austin Pass, Mount Baker, Washington) in the new millenium, you'd need access to a helicopter or have to be in good enough shape to climb for every turn you make.

Not every leap off a cornice is perfect. Sometimes the skier's ambition exceeded his ability, and Ray sometimes wished he had a movie camera so he could add the ending crash to his blooper reel of Mount Baker in 1953.

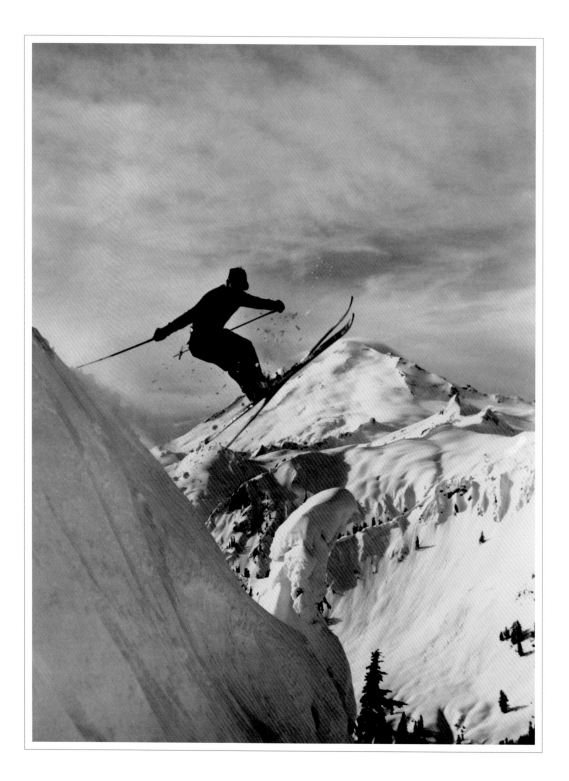

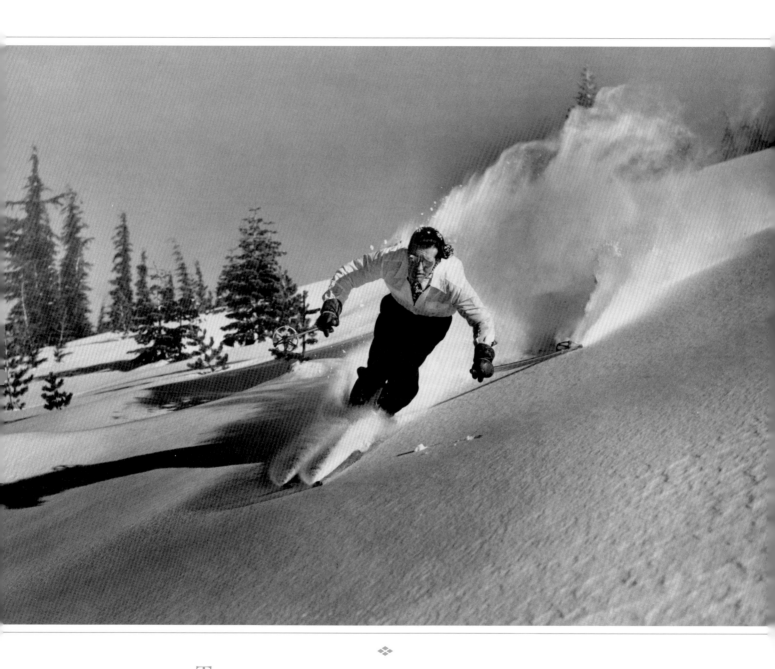

The 1930s, '40s, and '50s snow pack was carved on wings of wood by
men of steel (like Jerry Hiatt, here) and women of grace. We owe them
for inventing everything from warm clothes to high-speed lifts so we can
enjoy a comfortable destination in our instinctive search for freedom.

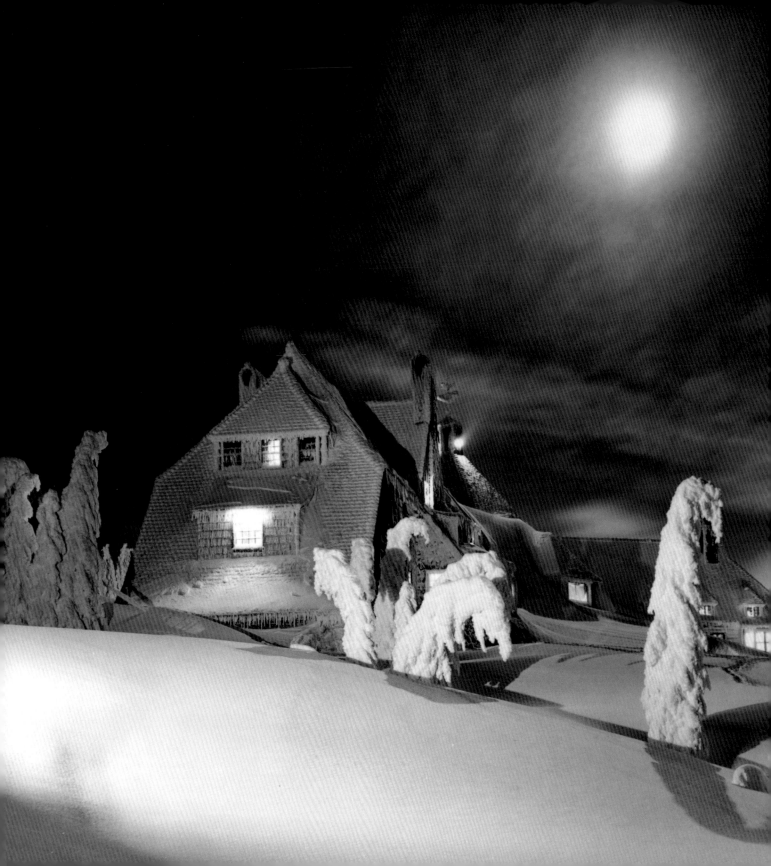

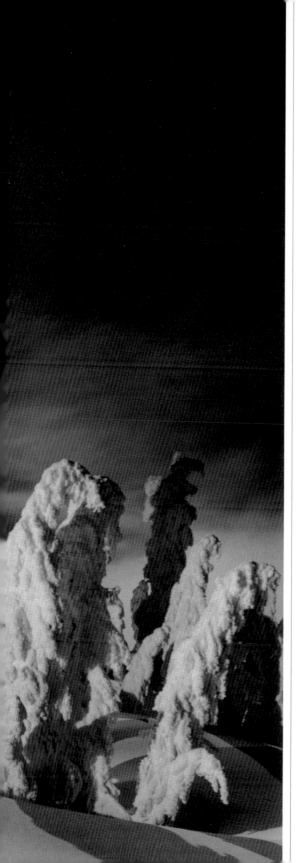

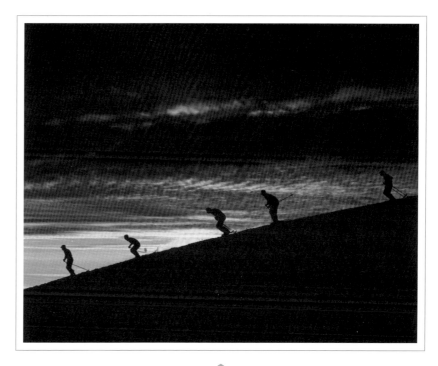

❖

To get this full moon shot (left) of Timberline Lodge with the slow film speed of the 1940s, Ray set up his tripod before the sun went down, positioned a person who held his flash bulb for him, waited for two hours after the moon had come up, and had a helper near the lodge to keep anyone from tracking up the snow. Then he had to guess at how long to expose the slow film (somewhere between five and ten minutes) to also get the moon to register. At the same time he hoped for the just-right amount of clouds to diffuse the moon. Other than that, this was just another easy photo for Ray Atkeson.

On the last run of the day (above) people sometimes hide in the trees until after the ski patrol has cleared the mountain so they can ski down alone, pausing occasionally to admire the scenery and perhaps listen to the shriek of a blue jay as they surprise it while it is busy eating a bit of food someone dropped from a chairlift.

These were the years that were black and white and snow all over. We had the same butterflies in our stomachs that you have today as you round the last bend in the road to your favorite ski resort on a sunny, powder-snow morning. By today's standards, our cars were small, our skis were long, and it took six of us to pool enough money to buy a tankful of twenty-five-cents-a-gallon gasoline and still have the dollar and a half left to buy an all-day rope tow ticket.

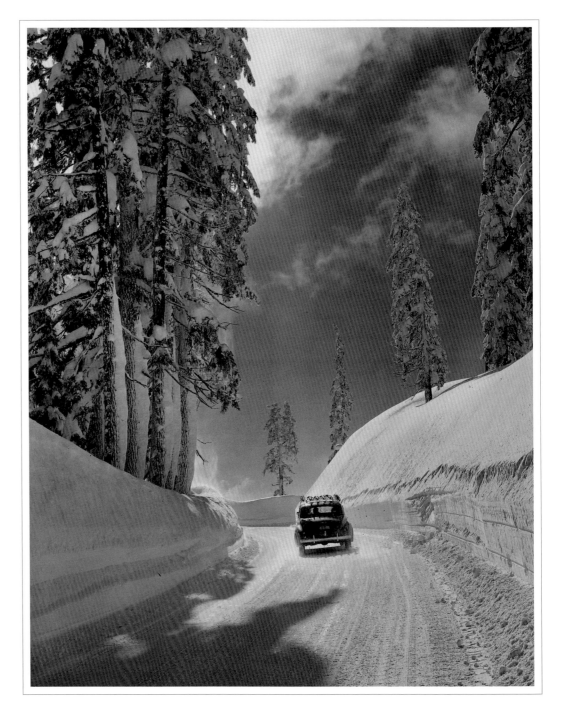